DIRECT RESPONSE

Rockport Publishers, Inc.
Gloucester, Massachusetts

First published in the United States of America by:
Rockport Publishers, Inc.
33 Commercial Street
Gloucester, Massachusetts 01930-5089
Telephone: (978) 282-9590
Facsimile: (978) 283-2742

Distributed to the book trade and art trade in the
United States by:
North Light Books, an imprint of
F & W Publications
1507 Dana Avenue
Cincinnati, Ohio 45207
Telephone: (800) 289-0963

Other Distribution by:
Rockport Publishers, Inc.
Gloucester, Massachusetts 01930-5089

ISBN 1-56496-480-9

10 9 8 7 6 5 4 3 2 1

Layout: SYP Design & Production
Cover Images (clockwise from top left):
Pages 11, 36, 46, 16, 47, 58, 33

Manufactured in Hong Kong.

Introduction

You are offered four different credit card accounts over the span of two weeks. You are made aware of a special on toilet paper at the local grocery store. Your alma mater sends you an update on how great they are doing, and how much greater they would be if they could have just a little bit more of your money. Ah, direct response marketing: people reaching out via regular and electronic mail to elicit your response to what important things they have to say. When it works, it is one of the most valuable marketing tools of our time.

In this *Direct Response* volume of the Design Library series, Rockport Publishers has brought together a collection of direct mail we know works. Leaf through the following pages and be inspired by the many different forms of direct response there are; from Websites to postcards, they all work as a call to action. With the help of this book, your success is inevitable in creating your own direct response marketing piece.

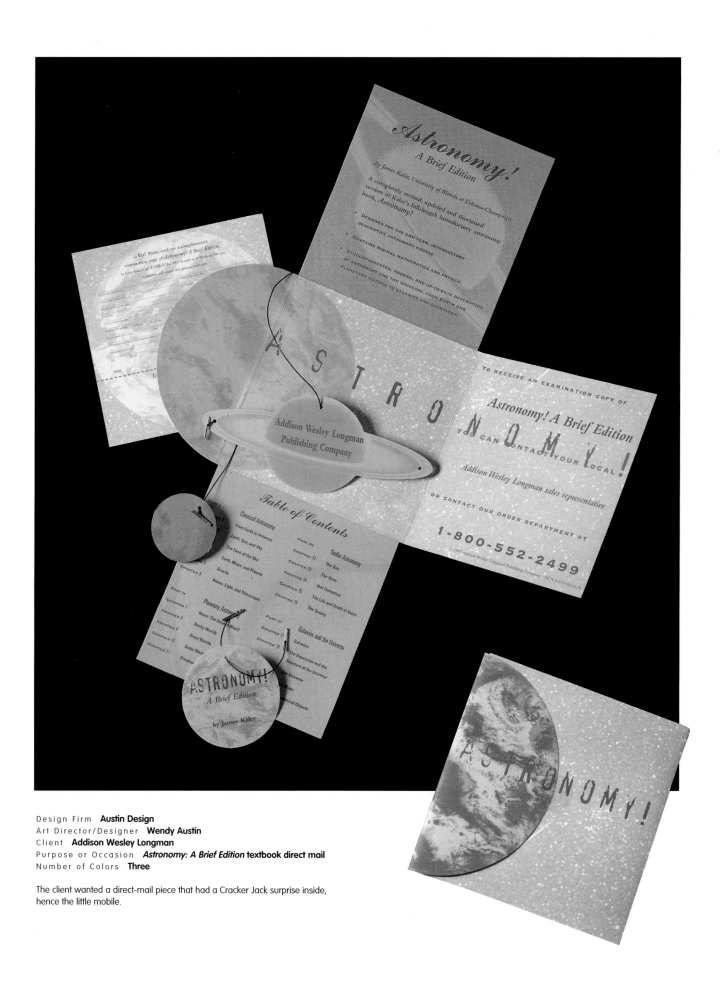

Design Firm **Austin Design**
Art Director/Designer **Wendy Austin**
Client **Addison Wesley Longman**
Purpose or Occasion ***Astronomy: A Brief Edition* textbook direct mail**
Number of Colors **Three**

The client wanted a direct-mail piece that had a Cracker Jack surprise inside, hence the little mobile.

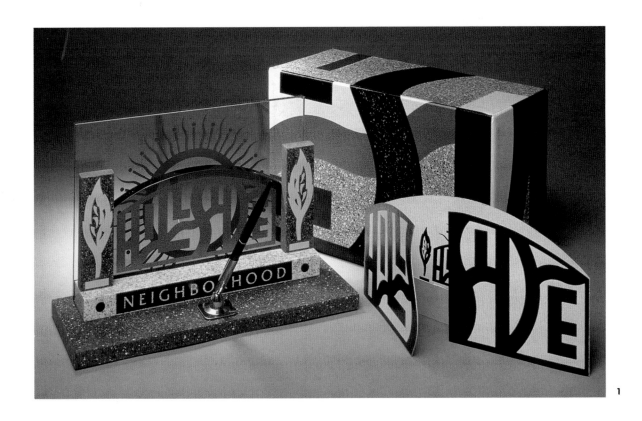

1

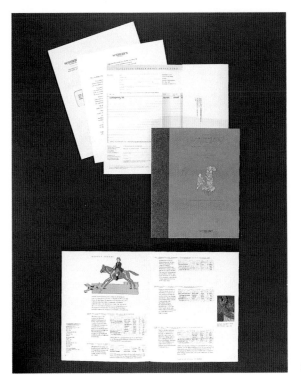

3

2

1
Design Firm **Sayles Graphic Design**
Art Director/Designer **John Sayles**
Illustrator **John Sayles**
Client **Hillside Neighborhood**

After designing a logo for Hillside Neighborhood, designer John Sayles fashioned a pen set which was sent as part of a promotional mailing to attract developers to the site.

2
Design Firm **O&J Design, Inc.**
Art Director **Andrzej J. Olejniczak**
Designer **Andrzej J. Olejniczak, I. Clara Kim**
Illustrator **Seymour Chwast**
Client **Sotheby's**

This elegant catalog sells hard by presenting fine art with a playful edge. According to its designer, Andrzej Olejniczak, "It commands attention, communicates with clarity and, most of all, rewards the reader for time well spent with it."

3
Design Firm **Vaughn Wedeen Creative**
Art Director **Steve Wedeen**
Designer **Steve Wedeen, Daniel Michael Flynn**
Illustrator **Daniel Michael Flynn, Kevin Tolman, Lendy McCullough**
Client **Jones Intercable**

Bright colors and a charming mix of graphic elements give this cable company's promotional mailer a cozy, informal look.

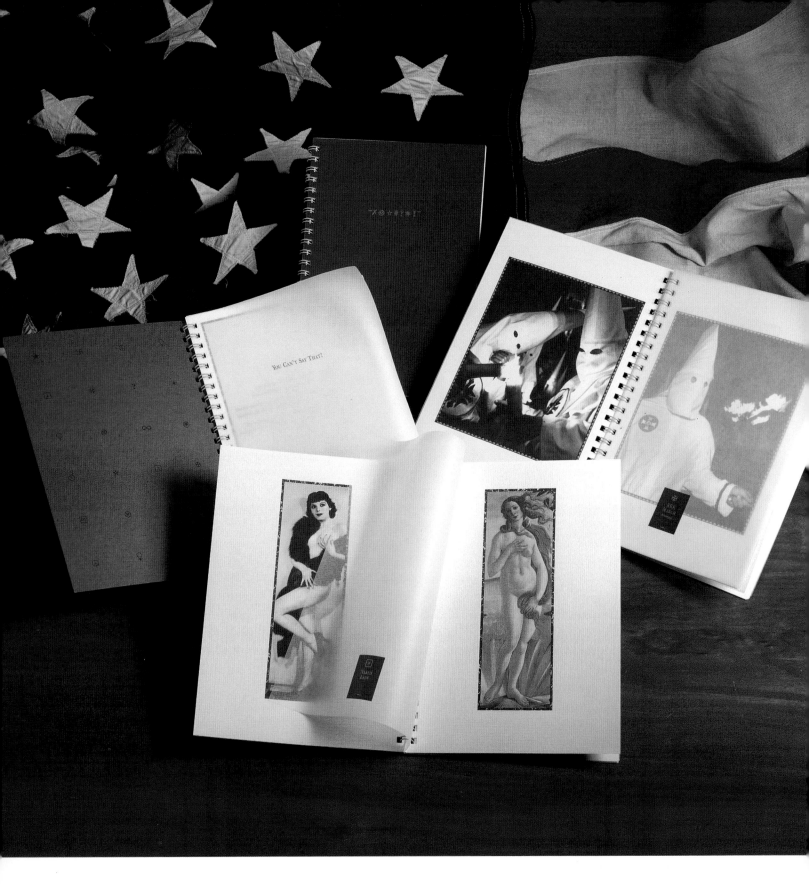

Design Firm **Bernhardt Fudyma Design Group**
Art Director **Craig Bernhardt**
Designer **Iris Brown**
Client **Gilbert Paper Company**

This paper promotion succeeded in attracting attention and stimulating
controversy by effectively integrating art and photography with political
subject matter. "Interest was generated in areas I wouldn't have expected,"
notes designer Craig Bernhardt, who says Gilbert Paper heard from many
nondesigners.

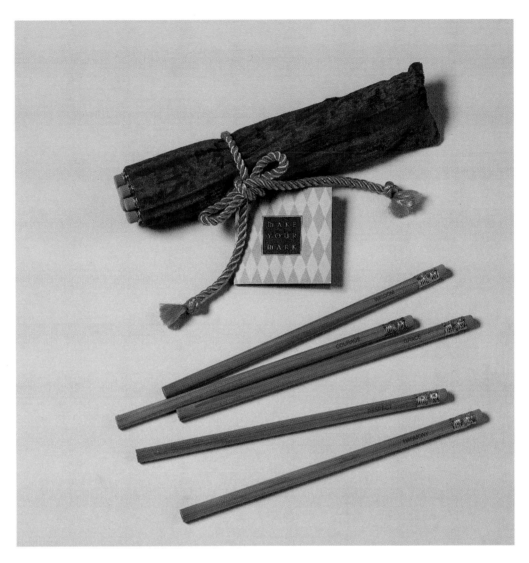

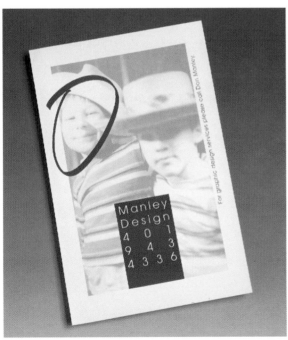

△
Design Firm **Melissa Passehl Design**
Art Director **Melissa Passehl**
Designers **Melissa Passehl, Charlotte Lambrects, David Stewart**
Writer **Susan Sharpe**
Purpose or Occasion **New Year greeting**
Paper/Printing **Evergreen, velvet, gold cord/Litho, foil stamp**
Number of Colors **Two**

Melissa Passehl Design created this gift set of pencils as a reminder to their clients that everyone has the communication tools to "Make Your Mark" in the New Year. Each pencil is foil stamped with words such as passion, humility, and respect.

◁
Design Firm **Manley Design**
Art Director/Designer **Don Manley**
Client **Manley Design**
Purpose or Occasion **Self-promotion**
Paper/Printing **Offset**
Number of Colors **Two**

This was a self-promotional ad that appeared on the inside back cover of a local Chamber-of-Commerce publication. This piece was created primarily with QuarkXPress and Adobe Photoshop.

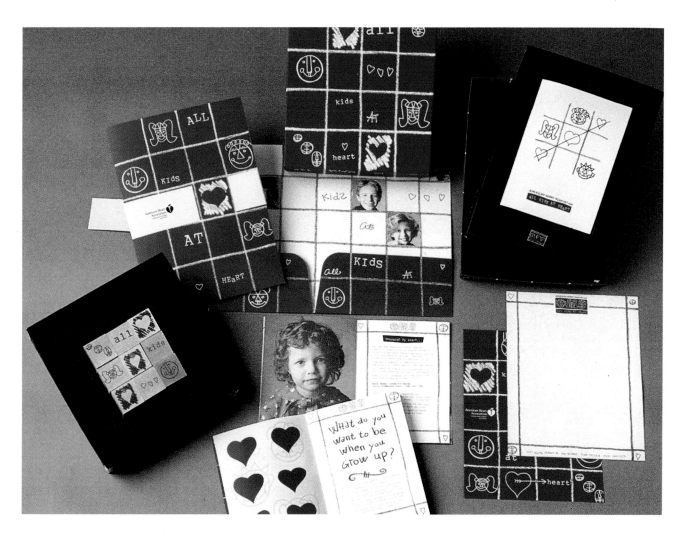

△

Design Firm **Sayles Graphic Design**
Art Director **John Sayles**
Designers **John Sayles, Jennifer Elliott**
Illustrator **John Sayles**
Client **American Heart Association**
Purpose or Occasion **Fund-raising brochure**
Paper/Printing **Hopper Hots, Flax Curtis Tuscan Terra, Curtis Terracoat/Screenprinting, offset**
Number of Colors **Two**

The logo and theme of the American Heart Association youth education program fund-raising materials reflect the purpose of the program: to educate Iowa's children about heart-healthy lifestyles. Designer John Sayles chose a "childlike" illustration style for the graphics of hearts and faces that appear throughout the collateral pieces. The brochure box includes an insert tray with an enamel "All Kids at Heart" lapel pin. The unique donor gift is a tic-tac-toe style game, made from wooden blocks with red screen-printed graphics. Rather than "x's" and "o's," players get three across with hearts and faces.

▷

Design Firm **Webster Design Associates, Inc.**
Art Director **Dave Webster**
Designer/Illustrator **Phil Thompson**
Client **AmeriServe Food Management**
Purpose or Occasion **Introduce AmeriServe**
Number of Colors **Two**

This direct-mail piece was created as a companion to an identity package designed for AmeriServe, an innovative new company offering health-oriented nutritional programs. The fresh, raw apple in the eye-catching wooden crate emphasized the slogan "Food for Thought." Copy describes the company's new approach.

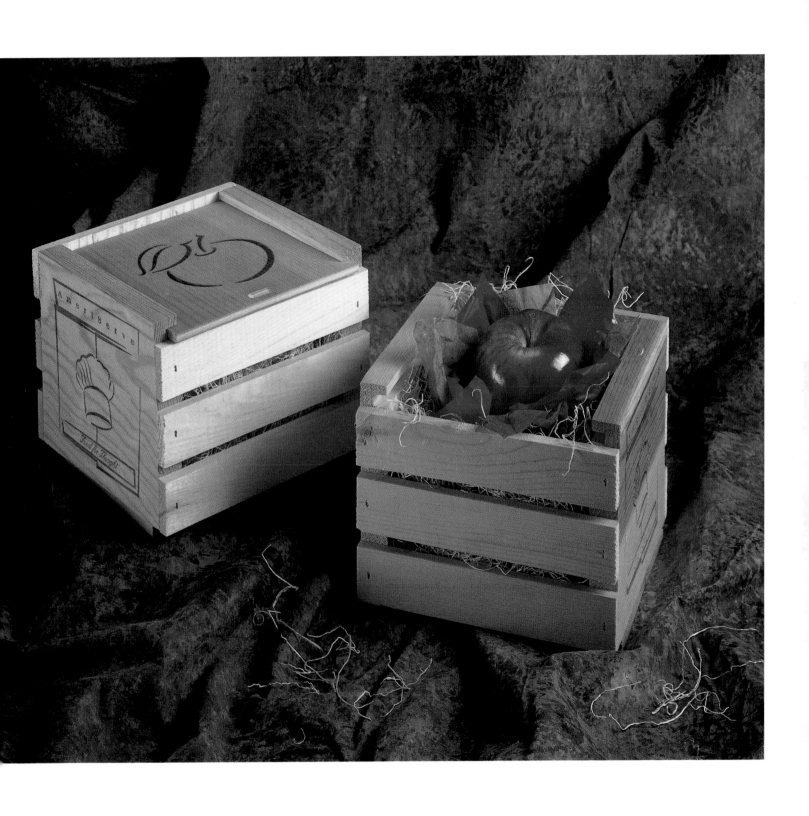

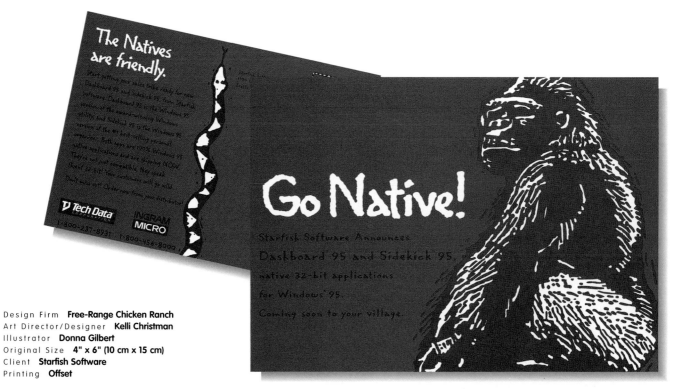

Design Firm **Free-Range Chicken Ranch**
Art Director/Designer **Kelli Christman**
Illustrator **Donna Gilbert**
Original Size **4" x 6" (10 cm x 15 cm)**
Client **Starfish Software**
Printing **Offset**

A series, the client wanted fun, inexpensive cards to send out announcing their new versions of software programs. Cost and timing were critical to concept—this was a rush project done in QuarkXPress.

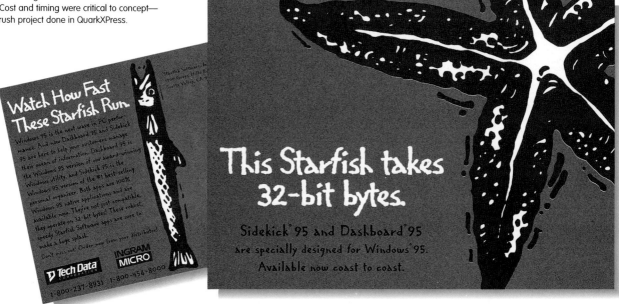

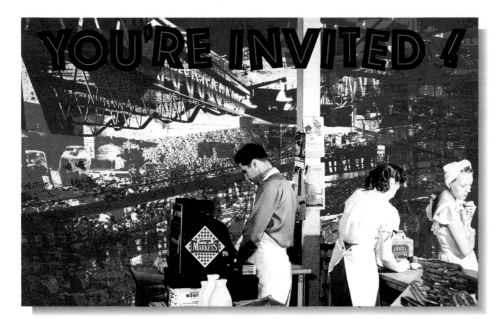

Design Firm **Art Chantry**
Art Director/Designer **Art Chantry**
Original Size **4 1/2" x 8" (11 cm x 20 cm)**
Client **Larry's Market**
Printing **Offset**

This invitation promotes the grand opening of a gourmet/deli-style supermarket.

This is a book about Jack.

Jack can't read.

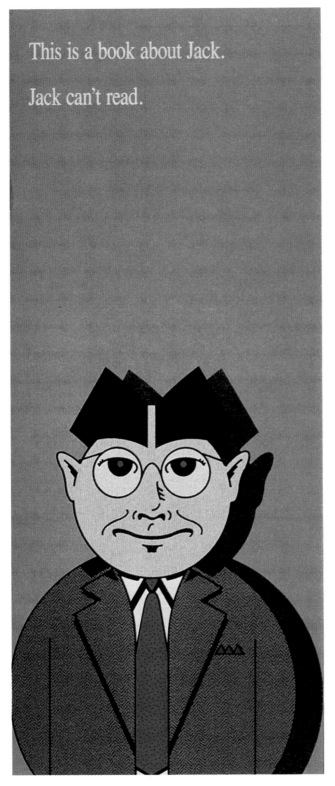

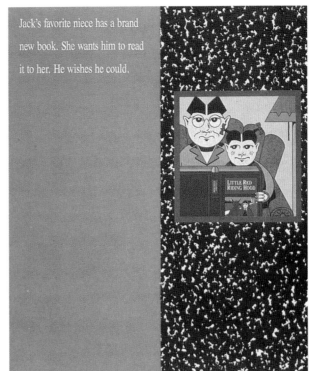

Jack's favorite niece has a brand new book. She wants him to read it to her. He wishes he could.

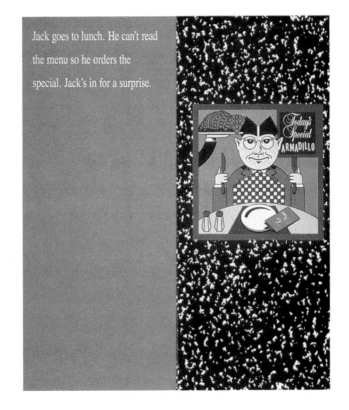

Jack goes to lunch. He can't read the menu so he orders the special. Jack's in for a surprise.

Design Firm **Vaughn Wedeen Creative**
Art Director/Designer **Steve Wedeen, Rick Vaughn, Gary Cascio**
Illustrator **Gary Cascio**
Client **Gilbert Paper**

This paper promotion, entitled "Jack Can't Read," was designed to push the press capabilities of Gilbert Oxford as well as express concern for illiteracy. "It works as a promotion, grabbing the design audience with color and graphics," says Wedeen, adding, "It's also been well received by literacy groups."

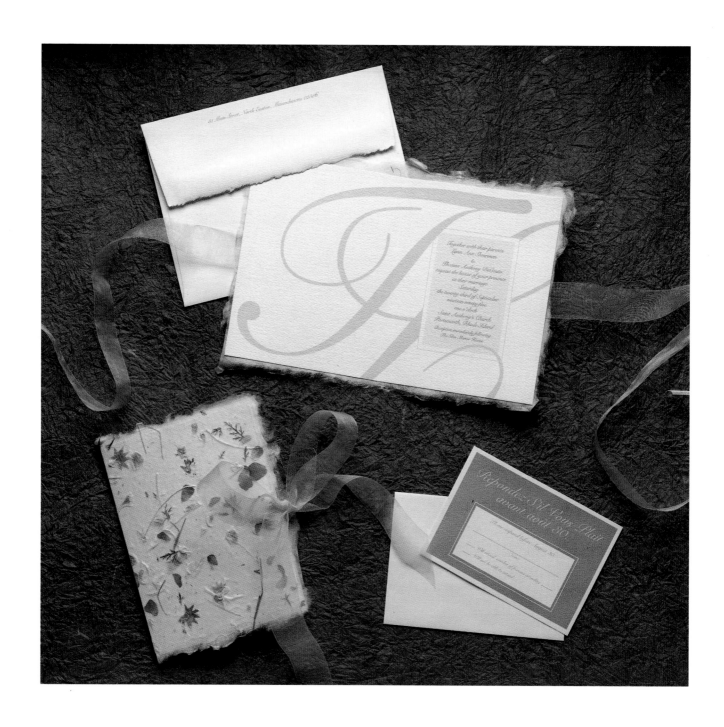

Design Firm **Clearpoint Communications**
Art Director/Designer **Lynn Decouto**
Client **Clearpoint Communications**
Purpose or Occasion **Wedding invitation**
Paper/Printing **Strathmore Pastelle/Reacraft Press**
Number of Colors **One**

This invitation was created by gluing handmade paper from Rugg Road Paper and a ribbon to the invitation, which was printed on Strathmore Pastelle. The artwork was created in QuarkXPress and printed in one color.

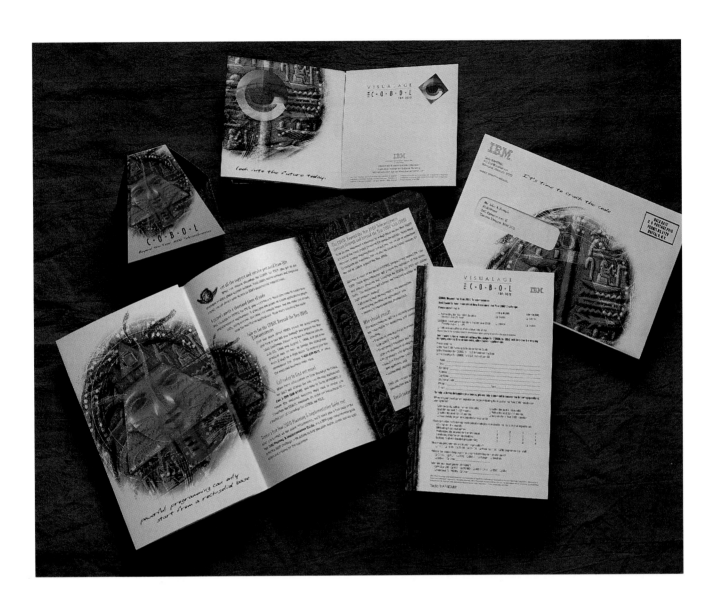

Design Firm **The Riordon Design Group, Inc.**
Art Director **Claude Dumoulin (FCB Toronto)**
Designer/Illustrator **Dan Wheaton**
Client **IBM (Cobol—Visual Age)**
Purpose or Occasion **Product launch for year 2000**
Paper/Printing **Potlach**
Number of Colors **Four**

These pieces, created digitally in Adobe Photoshop, Adobe Illustrator, and QuarkXPress, were designed to promote IBM's cobol product for Visual Age. The tag line was "Crack of Code" referring to the change for all computers at the turn of the century. Egyptian hieroglyph symbols were used as a visual metaphor. The success of this campaign was exceptional, both in response and awards.

Design Firm
Becker Design

Art Director/Designer
Neil Becker

Project
Brochure for lamp manufacturer

Client
Shady Lady

Purpose or Occasion
Brochure for lamp manufacturer

Software
Adobe Photoshop, Adobe Illustrator, QuarkXPress

Hardware
Macintosh 8500

▶ This piece was mailed to potential buyers of lamps and lighting accessories who were attending a lighting industry trade show.

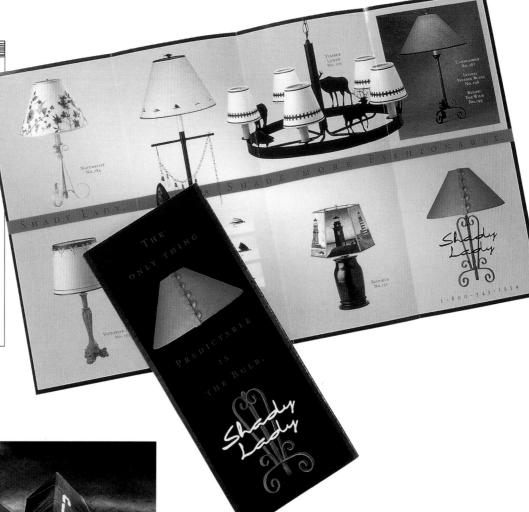

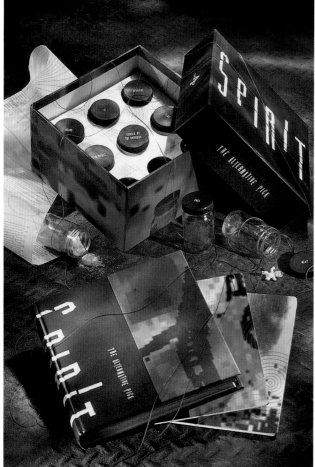

Design Firm
Planet Design Company

Art Directors
Dana Lytle, Kevin Wade

Designers
Kevin Wade, Darci Bechen

Project
Alternative pick logo

Client
Storm Music

Software
Adobe Photoshop, QuarkXPress

Hardware
Power Macintosh

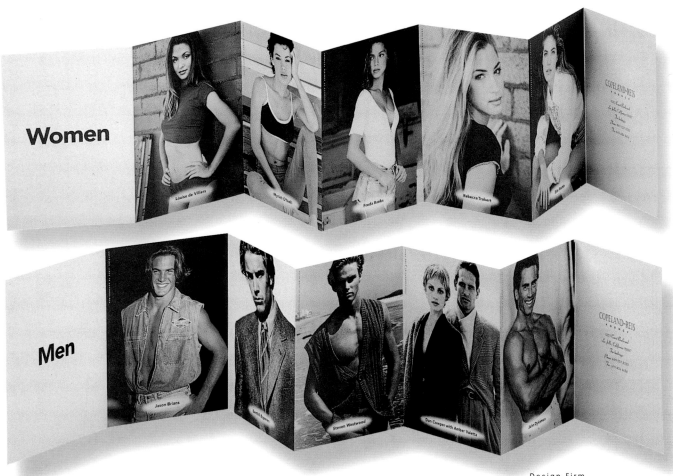

Women

Men

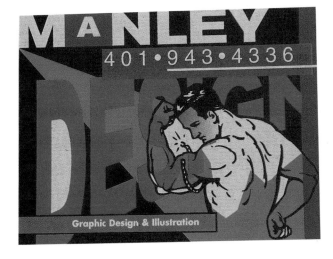

Design Firm
Manley Design
All Design
Don Manley
Client
Don Manley
Purpose or Occasion
Promotion
Paper/Printing
Neenah classic laid cover/Inkjet printer
Number of Colors
Printed in-house, 300 dpi HP inkjet printer

Every few months throughout the year, the designer sends out promotional postcards as a fun reminder of his design services. The cards are produced in-house on an HP 300 dpi color inkjet printer. Recipients enjoy the humorous, lighthearted approach and often mount the cards in their offices.

Design Firm
Mires Design
Art Director
John Ball
Designers
John Ball, Miguel Perez
Client
Copeland Reis Talent Agency
Purpose or Occasion
Promotion
Paper/Printing
Vintage Velvet
Number of Colors
One

A simple design proved an effective way to show prospective clients what this talent agency had to offer.

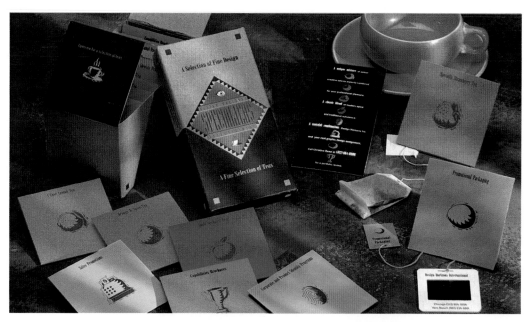

1

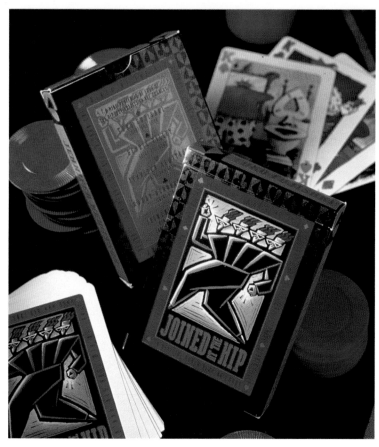

2

1
Design Firm **Design Horizons International**
Art Director **Bryan Sanzotti**
Designer **Janan Cain**
Photographer **Aldus Sauley**
Illustrator **Janan Cain**
Client **Design Horizons International**

Slides of portfolio samples masquerade as tea bags in this clever promotional strategy. Sent to prospective clients as an introductory promotion, "it was really well received," says the firm's account executive Christine Bassi.

2
Design Firm **Mires Design, Inc.**
Art Director/Designer **José Serrano**
Illustrator **Jennifer Hewitson**
Client **Joined At The Hip**

A collaborative promotional effort by a group of illustrators yielded this unusual deck of playing cards. Each card shows an illustration sample on one side, and has the illustrator's name, address, and phone number on the reverse.

3 (*opposite page*)
Design Firm **Mike Quon Design Office**
Art Directors **Mike Quon, T. Alpert**
Designer **Mike Quon**
Illustrator **Mike Quon**
Client **New York Telephone**

Intriguing numbers suggesting a business solution lie within this business-to-business mailer. Designer Mike Quon says New York Telephone wanted to stress business relationships and accessibility with this piece.

The Customer Partnership Program matches senior executives

One

from the region's premier companies with executives from

On

New York Telephone, one on one. This forum allows decision

One

makers to understand both sides of the business equation.

Promotion

Design Firm
Schwartz Design

Art Director/Designer
Bonnie Schwartz

Illustrator
Tracy Sabin

Project
Center for Executive Health brochure

Client
Scripps Memorial Hospital

Purpose or Occasion
Promotional brochure

Software
Adobe Illustrator

Hardware
Macintosh 9500

▶ The illustration was created for a brochure directed at business executives that outlines the available health-care services. A positive, light-hearted approach to the graphics was deemed appropriate.

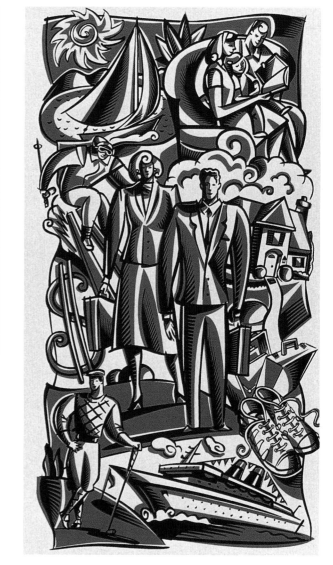

Promotion

Design Firm
Parham Santana, Inc.

Art Director
Elisa Feinman/USA Networks

Designers
John Parham, Dave Wang

Project
Grand Slam Tennis on USA

Client
USA Network

Purpose or Occasion
Sales/promotion kit

Software
Adobe Photoshop, Adobe Illustrator, QuarkXPress

Hardware
Macintosh 8500

▶ This is a sales/promotion kit for cable rights to two grand-slam tennis events on USA Network. The kit is characterized by bold yet elegant style for programming that targets an exclusive demographic. Player images were blurred and silhouetted on metallic and color backgrounds and a simulated foil stamp embossing was achieved using Adobe Photoshop.

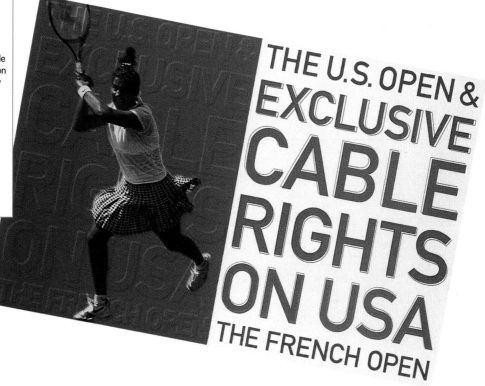

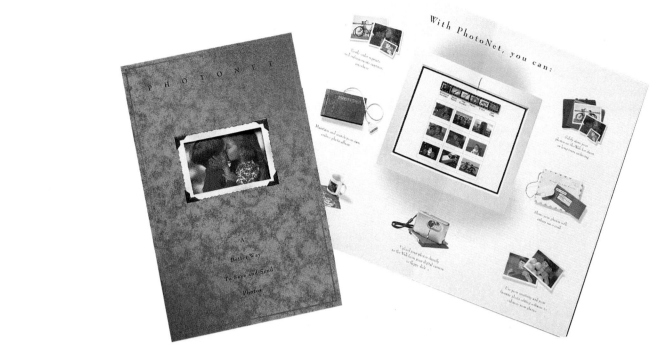

△
Design Firm **Hornall Anderson Design Works**
Art Director **David Bates**
Designers **David Bates, Margaret Long**
Client **PhotoNet**
Purpose or Occasion **Capabilities brochure**
Paper/Printing **Mohawk Superfine**

PhotoNet is a provider of a service that digitalizes photographs. This service is provided through camera stores. The brochure was designed using Macromedia FreeHand, Adobe Photoshop, and QuarkXPress.

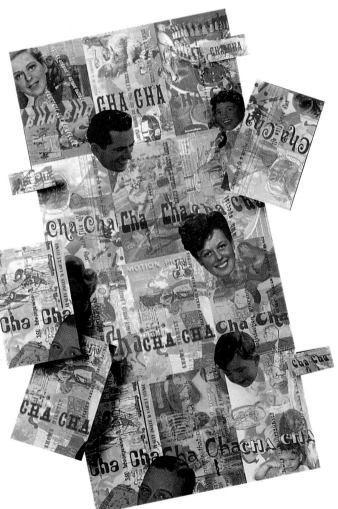

◁
Design Firm **Planet Design Company**
Art Directors **Kevin Wade, Dana Lytle**
Designers **Kevin Wade, Darci Bechen**
Photographer **Mark Salisbury**
Client **Cha Cha Beauty Parlor and Haircut Lounge**
Purpose or Occasion **Poster, grand opening postcard set**
Paper/Printing **Offset**
Number of Colors **Four**

Cha Cha Beauty Parlor and Haircut Lounge is a truly one-of-a-kind hair salon. The poster was created with a fresh and funky image in mind. Since budget was an issue, the designers printed a direct-mail campaign on the back of the poster, which was then cut into twelve ready-to-send direct-mail cards.

Design Firm **My Table**
Art Director **Byrne-Dodge**
Original Size **5" x 3 1/2" (13 cm x 9 cm)**
Illustrator **Brian Kirchner**
Printing **Offset**

This was the designer's first foray into color—
My Table, a bimonthly dining-out magazine,
is black-and-white only—and she wanted a
promotional/direct-response piece that
would reflect the whimsical, un-slick quality of
the publication. The card brought a 10
percent response; even better were the
compliments from the many people who
liked the card.

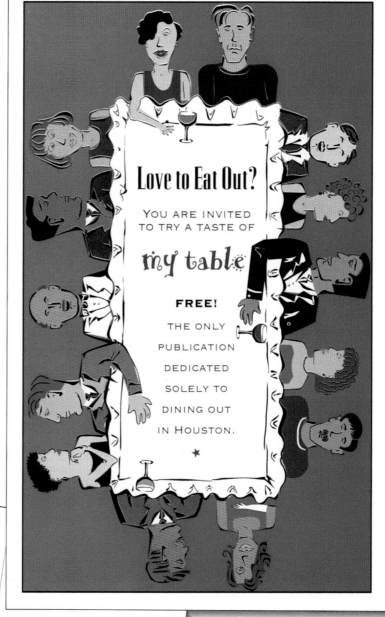

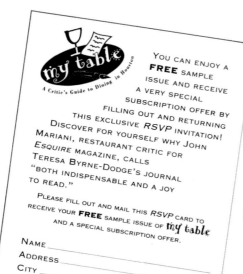

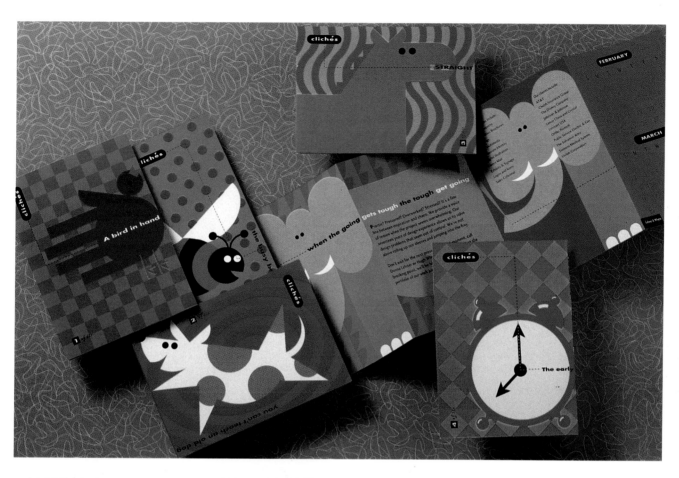

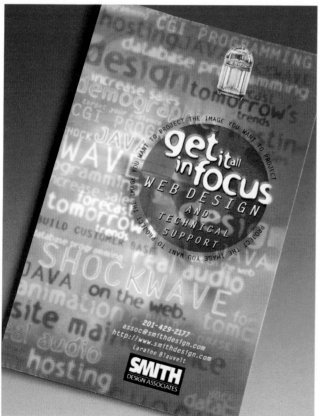

This bi-monthly calendar was mailed to clients and potential clients. The theme was clichés, shown in a illustrative design style over backgrounds created in Adobe Illustrator. Photographic backgrounds were used for overall textures. The piece was created in Adobe Photoshop and QuarkXPress.

The objective was to create a postcard promoting the design firm's services for Web design. The unfocused image in the background represents the feelings of many people concerning the deluge of new technology and terminology facing them daily. The concept is that Smith Design Associates can "get it all in focus" from design to technical support, and will help businesses project the image they want on the Web. The jukebox image ties into the Website and the decor of the firm.

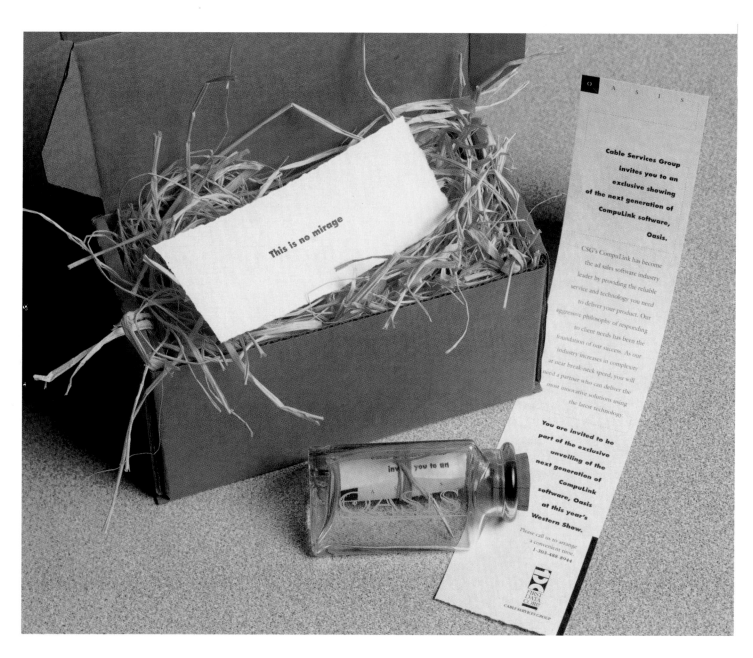

Design Firm **Webster Design Associates, Inc.**
Art Director **Dave Webster**
Designers **Dave Webster, Phil Thompson**
Client **Cable Services Group**
Purpose or Occasion **Invitation to a special showing**
Number of Colors **One**

This high-tech message in a bottle was sent to managers to invite them to
the exclusive unveiling of Oasis, a new software system for monitoring cable-
television subscribers.

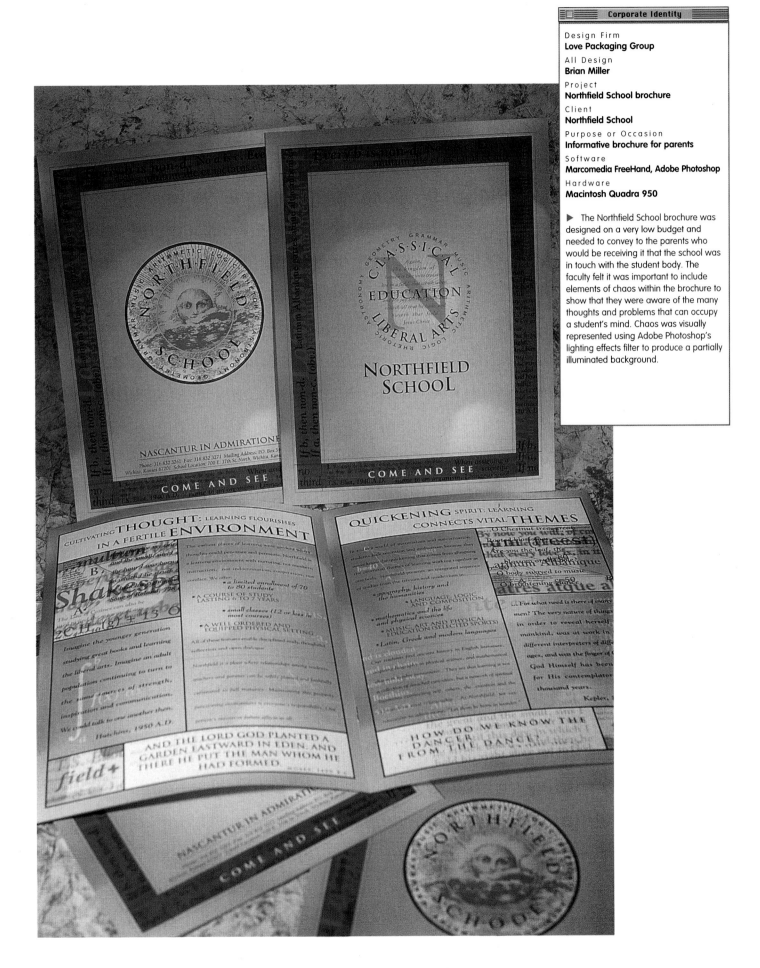

Corporate Identity

Design Firm
Love Packaging Group

All Design
Brian Miller

Project
Northfield School brochure

Client
Northfield School

Purpose or Occasion
Informative brochure for parents

Software
Marcomedia FreeHand, Adobe Photoshop

Hardware
Macintosh Quadra 950

▶ The Northfield School brochure was designed on a very low budget and needed to convey to the parents who would be receiving it that the school was in touch with the student body. The faculty felt it was important to include elements of chaos within the brochure to show that they were aware of the many thoughts and problems that can occupy a student's mind. Chaos was visually represented using Adobe Photoshop's lighting effects filter to produce a partially illuminated background.

Design Firm
Anchorage Daily News

All Design
Lance Lekander

Project
Get Wired

Client
Anchorage Daily News

Purpose or Occasion
Weekly entertainment section

Software
Adobe Illustrator, Adobe Dimensions, Adobe Photoshop

Hardware
Macintosh 9500/132 80

▶ This illustration went along with an article about coffee shops with Internet connections. The headline, cup, saucer, and computers were rendered in Dimensions, the background spiral buzzsaw pattern was made in Illustrator. All elements were then combined in Photoshop.

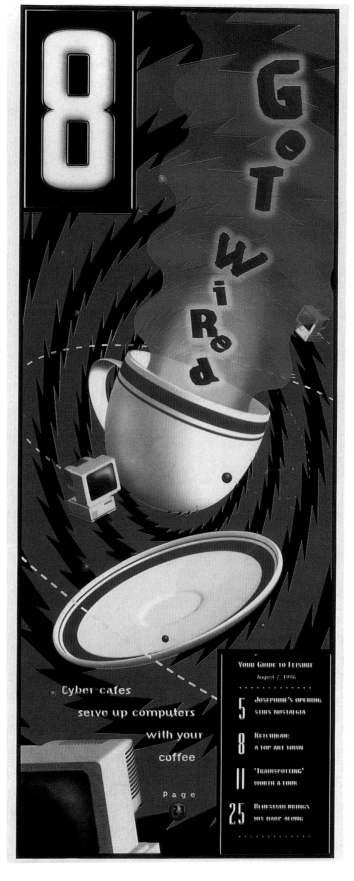

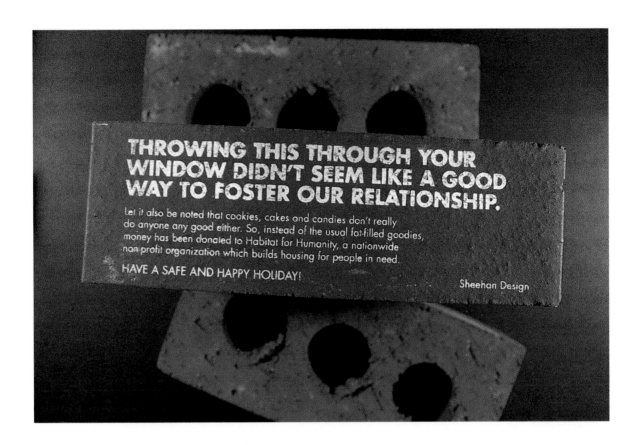

THROWING THIS THROUGH YOUR WINDOW DIDN'T SEEM LIKE A GOOD WAY TO FOSTER OUR RELATIONSHIP.

Let it also be noted that cookies, cakes and candies don't really do anyone any good either. So, instead of the usual fat-filled goodies, money has been donated to Habitat for Humanity, a nationwide non-profit organization which builds housing for people in need.

HAVE A SAFE AND HAPPY HOLIDAY!

Sheehan Design

Design Firm
Sheehan Design

Art Director/Designer
Jamie Sheehan

Client
Sheehan Design

Purpose or Occasion
Holiday promotion

Paper/Printing
Bricks

Number of Colors
One

Using bricks, my intention was to poke fun at the standard holiday gorging while making it known that money was donated to charity in place of an expensive gift to the recipient. The bricks were wrapped in fancy paper and delivered by courier to local clients. The design for the text was done using a computer and printed using silkscreen.

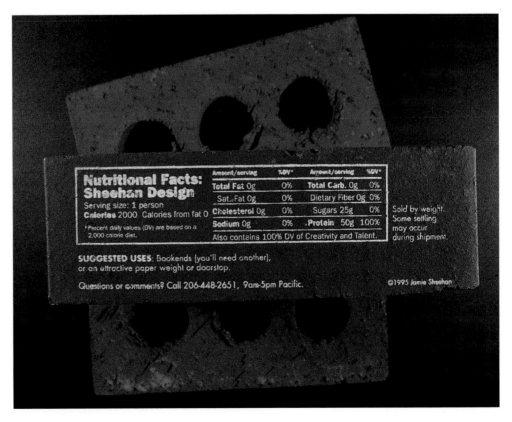

Nutritional Facts: Sheehan Design

Serving size: 1 person
Calories 2000 Calories from fat 0

*Percent daily values (DV) are based on a 2,000 calorie diet.

	Amount/serving	%DV*	Amount/serving	%DV*
Total Fat 0g		0%	**Total Carb.** 0g	0%
Sat. Fat 0g		0%	Dietary Fiber 0g	0%
Cholesterol 0g		0%	Sugars 25g	0%
Sodium 0g		0%	.**Protein** 50g	100%

Also contains 100% DV of Creativity and Talent.

Sold by weight. Some settling may occur during shipment.

SUGGESTED USES: Bookends (you'll need another), or an attractive paper weight or doorstop.

Questions or comments? Call 206-448-2651, 9am-5pm Pacific.

©1995 Jamie Sheehan

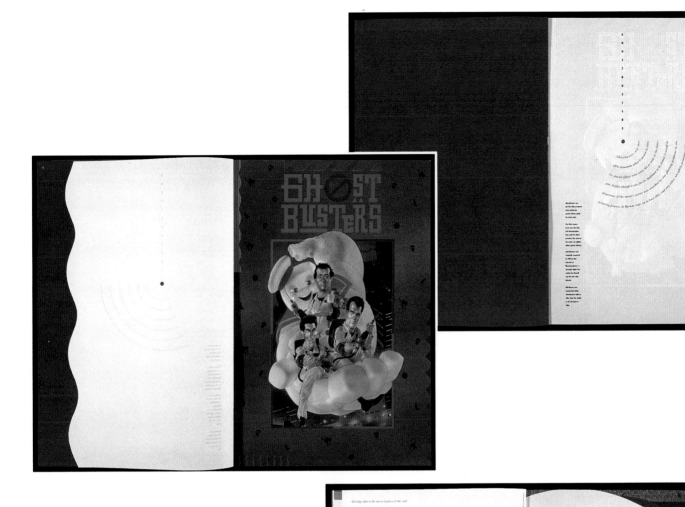

Design Firm
Rickabaugh Graphics
Art Director/Designer
Eric Rickabaugh
Photographer
Paul Poplis
Illustrator
Fred Warter Michael Tennyson Smith, Eric Rickabaugh
Client
Byrum Lithographing

Showing off a printer's capabilities provided an opportunity for showcasing great design. This promotional brochure and series of posters opened doors for the client and Rickabaugh Graphics. "It's cinched a lot of deals for us," says firm principal Eric Rickabaugh.

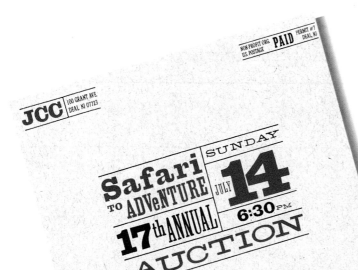

Design Firm **Howard Levy Design**
Art Director/Designer/Illustrator **Howard Levy**
Original Size **7" x 7" (18 cm x 18 cm)**
Client **Jewish Community Center of Greater Monmouth, New Jersey**
Printing **Offset**

This postcard is the first in a series of mailings publicizing a fund-raising auction with a safari theme. Each mailing will have a different animal, with a different animal pattern in a different color.

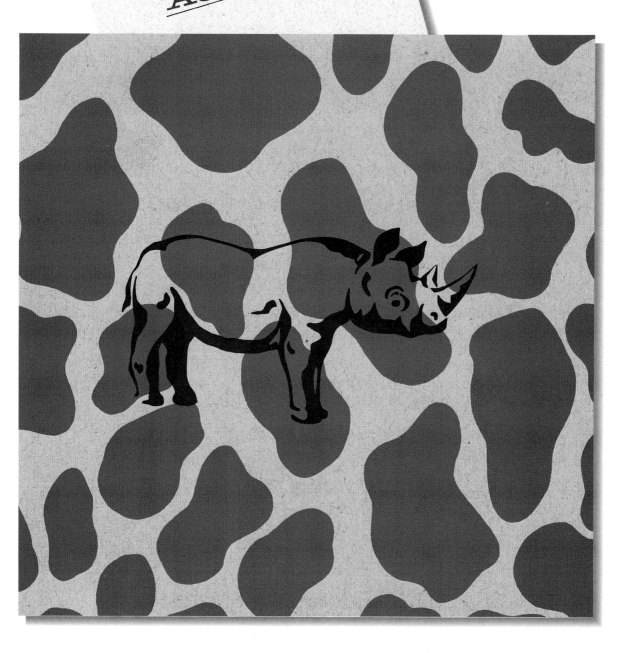

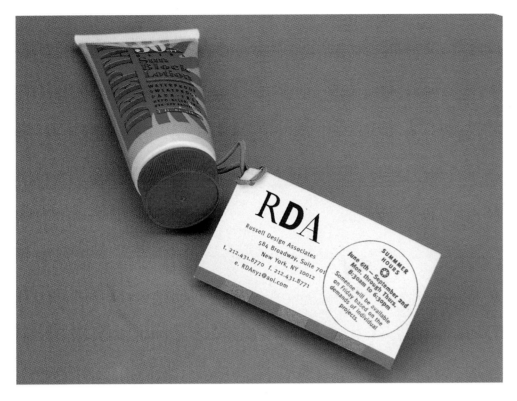

Design Firm
Russell Design Associates

Art Director
Anthony Russell

Designer
Mara Strasberg

Client
Russell Design Associates

Purpose or Occasion
Summer-hours announcement

Paper/Printing
Strathmore Writing/Offset

Number of Colors
Four

Using just a blank business card, rubber stamp, bottle of suntan lotion, and a hairband, Russell Design Associates was able to create a memorable direct-mail piece to announce the summer-hours schedule.

Design Firm
Val Gene Associates—Restaurant Group

Art Director/ Designer
Lacy Leverett

Photographer
Mark Hancock

Client
Texanna Red's Restaurant and Cantina

Purpose or Occasion
Grand reopening announcement

Paper/Printing
Baker's Printing

Number of Colors
One

This announcement featured a photo of a 1949 bus, which was crashed into the side of the building during a recent remodeling. Tabasco, antacid, and a beer-bottle cap were a fun, whimsical way to give an idea about the restaurant's atmosphere. Date, time, and location were left blank until details became available.

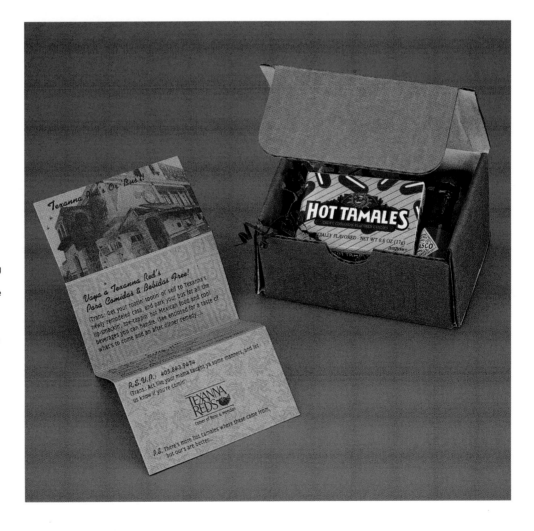

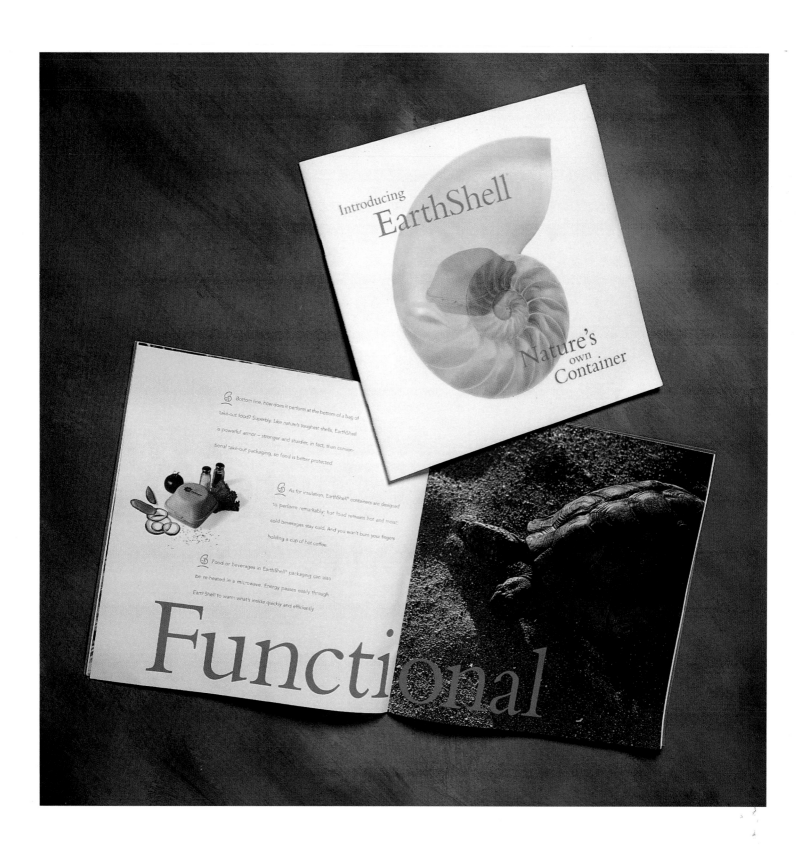

Design Firm **Hornall Anderson Design Works**
Art Director **John Hornall**
Designers **John Hornall, Jana Nishi, Bruce Branson-Meyer**
Illustrator **Julia LaPine**
Client **EarthShell Container Corp.**
Purpose or Occasion **Capabilities brochure**
Paper/Printing **Glama Natural 29 lb. vellum, Mohawk Opaque Brilliant White**

The client wanted a look and feel that connected them and their product with nature. The client creates disposable, fast-food packaging and needed a capabilities brochure that would introduce their product to restaurants. The brochure simplifies technical information for reader-friendly, sales purposes.

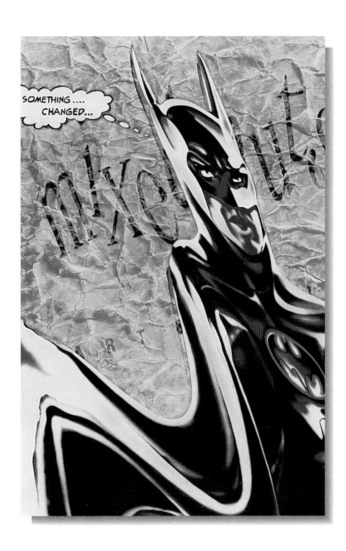

Design Firm **Mixed Nuts Inc.**
Art Director/Illustrator **Bill Boyko**
Designer **Cara Lynn Rumack**
Original Size **6" x 4" (15 cm x 10 cm)**
Purpose/Occasion **Change of address/self-promotion**
Printing **4-color**

Gouache, pencil, ink, and collage with an illustrated Batman figure keyed into the Batman movies, popular at the time of the concept.

Design Firm **Bluestone Design Ltd.**
Art Director **S. Kyffin**
Original Size **4" x 7 1/2" (10 cm x 19 cm)**
Printing **Lithography**

The piece, created in Adobe Photoshop, fit into a direct-mail push to generate awareness of the firm before it sent the main part of the campaign—a brochure.

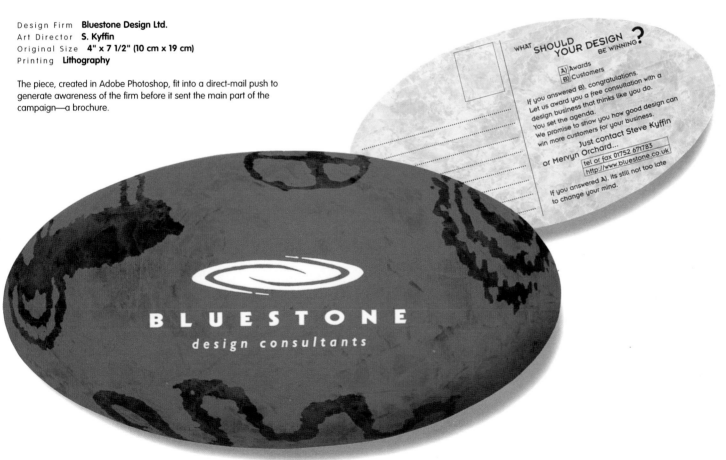

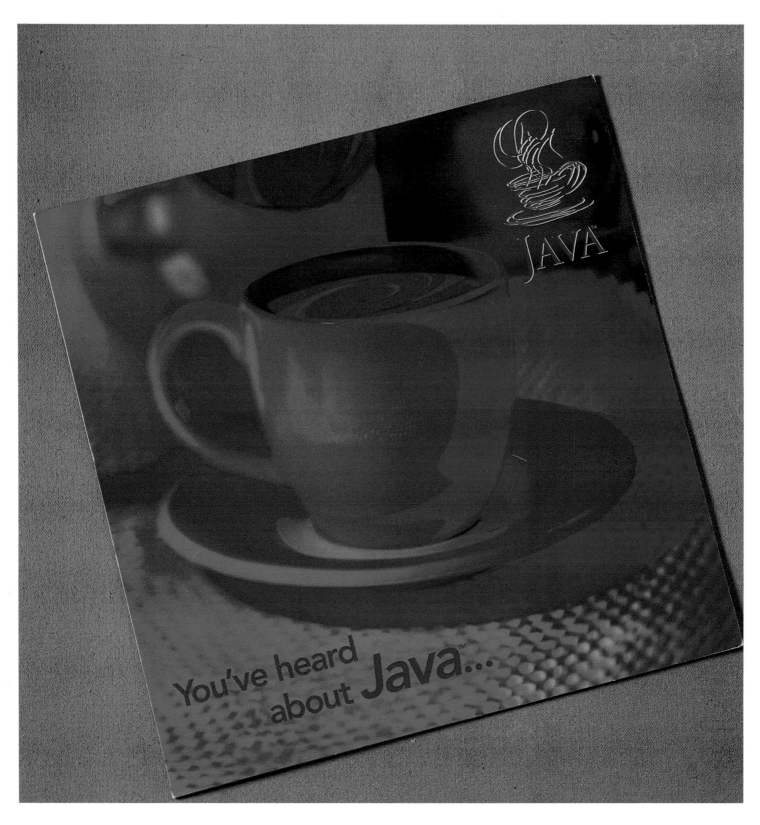

Design Firm **Directech, Inc.**
Art Director **Christine Rosecrans**
Designer **Lynne Miller**
Photographer **Greg Klim**
Photo Retoucher **Dave Kaupp**
Client **Sun Microsystems, Inc.**
Purpose or Occasion **Product promotion—Java Workshop**
Paper/Printing **Centura gloss white 100 lb. cover/W. E. Andrews**
Number of Colors **Eight**

To introduce Sun's new Java workshop and create product excitement, this self-mailer uses an unusual breakthrough format, special-effects photography, and exciting graphics.

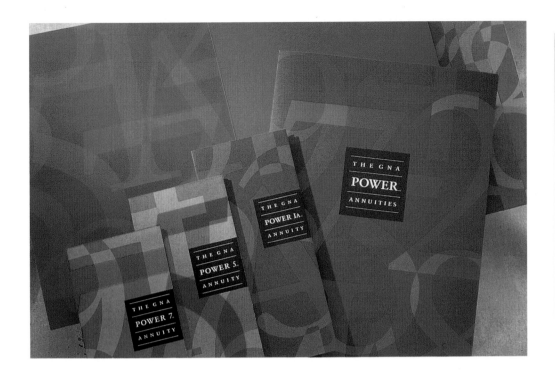

Product

Design Firm
Hornall Anderson Design Works

Art Director
Jack Anderson

Designers
**Jack Anderson, Lisa Cerveny,
Jana Wilson, Suzanne Haddon**

Project
GNA power annuities kit

Client
GNA

Purpose or Occasion
Marketing kit

Software
Adobe Illustrator, QuarkXPress

Hardware
Macintosh

▶ This is the first in a series of product
launches for GNA that will be used in
presentations to potential clients as a
means of representing the company's
capabilities and services.

Product

Design Firm
Design Art, Inc.

Art Director/Designer
Norman Moore

Project
Panavision advertising campaign

Client
Panavision Hollywood

Software
**Adobe Photoshop, Adobe Illustrator,
QuarkXPress**

Hardware
Macintosh 9500/150

▶ Panavision wanted to get away from
their previous series of serious-looking
ads and present an image that was
more accessible and humorous. Stock
photos and still lifes were composed in
Photoshop and colorized, with final
assembly in QuarkXPress.

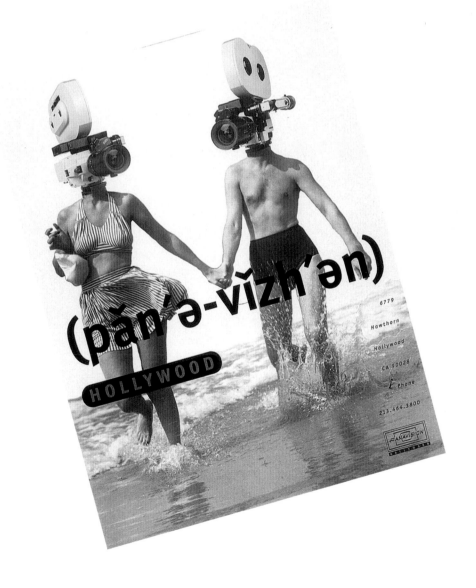

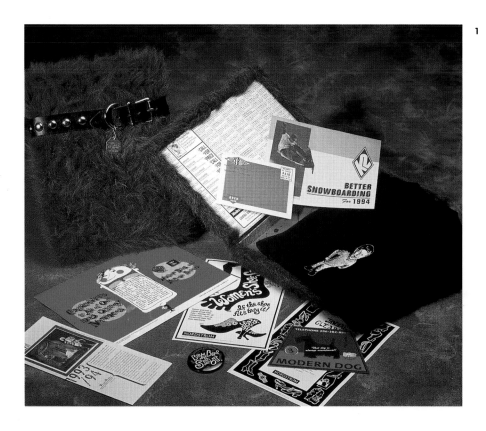

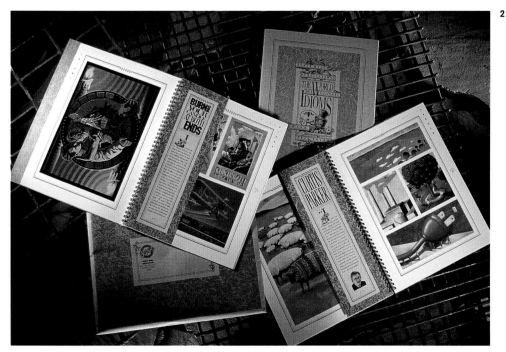

1
Design Firm **Modern Dog**
Art Director **Michael Strassburger**
Designers **Michael Strassburger, Robynne Rayet, V. Costarella**
Client **Modern Dog**

This unique self-promotion, packaged in an authentic fur box, helped to land some big-time clients such as Fox Television and Capitol Records.

2
Design Firm **Scott Hull Associates, Rickabaugh Graphics**
Art Director/Designer **Eric Rickabaugh**
Illustrator **Scott Hull Associates**
Copywriter **Jeff Morris**
Clients **Scott Hull Associates, Rickabaugh Graphics, Emerson Press**

Bringing ideas to life through illustrations of idioms is the theme of this brochure. Firm principal Scott Hull says it was conceived to have staying power. "I thought it would serve as a source that our clients could refer to time and again—a piece that would stay on their shelves for years."

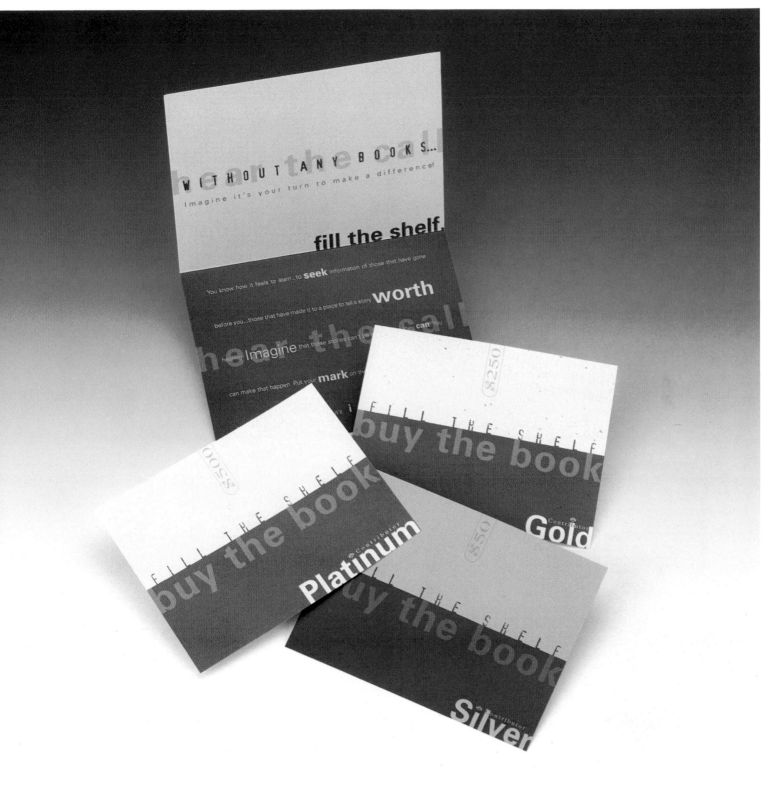

Design Firm **Shook Design Group, Inc.**
Designers **Ginger Riley, Graham Schulken**
Client **UNC—Charlotte College of Architecture**
Purpose or Occasion **Solicitation for donations**
Paper/Printing **Classic Crest**
Number of Colors **One**

Shook Design Group, Inc. designed an invitation to donate funds to
benefit the UNC—Charlotte's purchase of 7,000 new books for its
College of Architecture library.

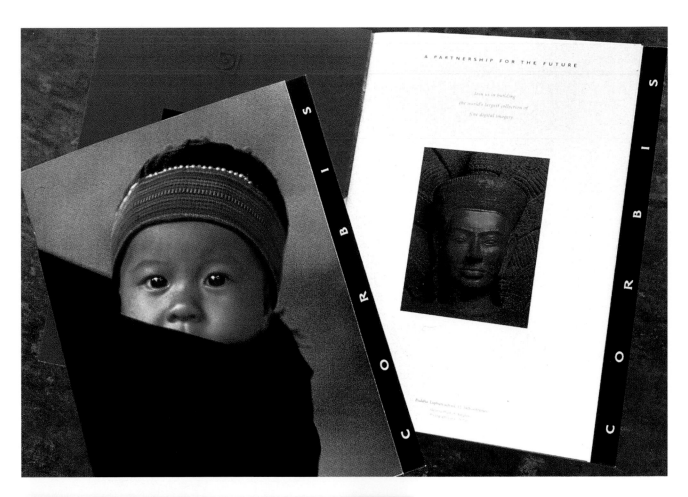

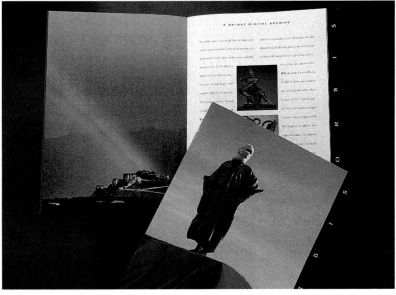

Design Firm **Hornall Anderson Design Works**
Art Director **Jack Anderson**
Designers **Jack Anderson, John Anicker, David Bates, Margaret Long**
Illustrator **Corbis archive**
Client **Corbis Corporation**
Purpose or Occasion **Promotional brochures for services**
Paper/Printing **Vintage Velvet**

The objective was to create two brochures, serving the same purpose, but for
different target audiences. One brochure targeted fine-art institutions and the
other targeted photographers. Corbis used the brochures to target specific
sources to the benefits of archiving their images under the Corbis umbrella. These
brochures were designed using QuarkXPress.

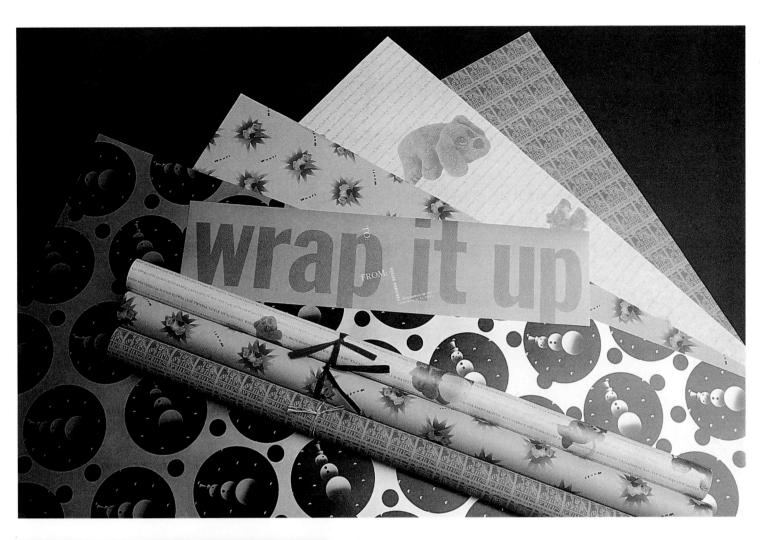

△
Design Firm **DHI (Design Horizons International)**
Art Director **Kim Reynolds**
Designers **Kim Reynolds, Mike Schacherer**
Illustrator **Krista Ferdinand**
Purpose or Occasion **Holiday self-promotion**
Number of Colors **Two**

The designers named this holiday self-promotion, "Wrapping Paper."

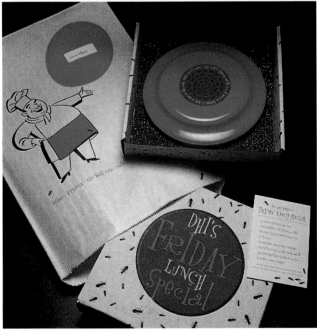

△
Design Firm **DHI (Design Horizons International)**
Art Director/Designer **Victoria Huang**
Purpose or Occasion **Self-promotion**
Number of Colors **Three PMS**

This summer self-promotional piece is titled, "DHI Friday Lunch Special."

Design Firm **MartinRoss Design**
Art Directors/Designers **Martin Skoro, Ross Rezac**
Client **Welsh & Associates for American Bank**
Purpose or Occasion **Direct marketing**
Number of Colors **Four plus varnish**

The client wanted to show business customers that their present bank may
be too small, so through photography and Adobe Photoshop, humorous
situations were created. The brochures are bright and appealing to the eye
and not as busy as much of the direct mail that's received. They have small
die-cut doors that open and give a hint of what's inside.

Design Firm **Tim Noonan Design**
Art Director/Designer **Tim Noonan**
Illustrator **Olivia McElroy**
Client **Elan Financial Services**
Purpose or Occasion **Open new Elan accounts**
Paper/Printing **Starwhite Vicksburg/Fox Printing Co.**
Number of Colors **Four PMS**

The sweepstakes was an incentive for employees of institutions participating
in the Elan Financial Services Credit Card Program to open new accounts.
Each time an employee opened a new Elan account, they would qualify for a
chance to win one of over 160 prizes. The prizes tied into the concept: "There's
No Place Like Home." Layout was created in QuarkXPress and the illustrations in
Macromedia FreeHand.

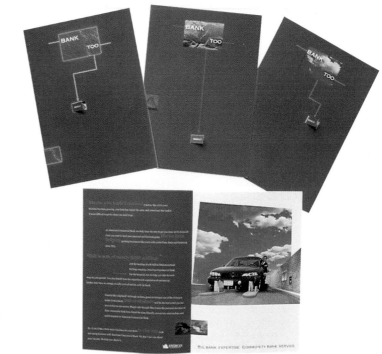

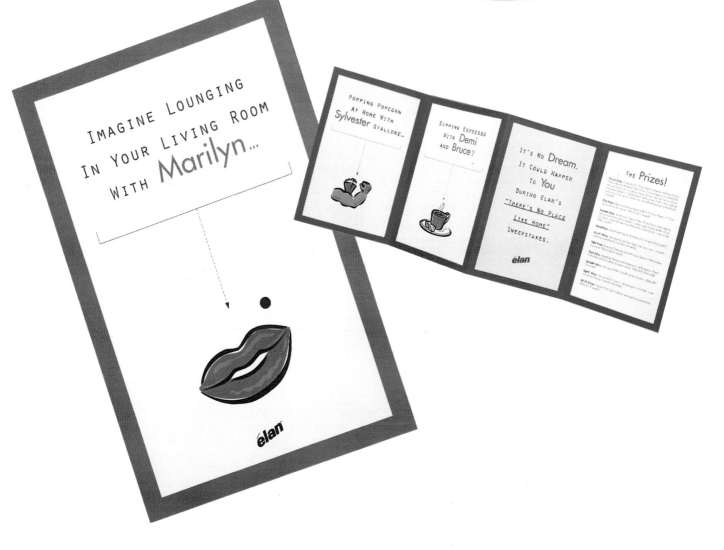

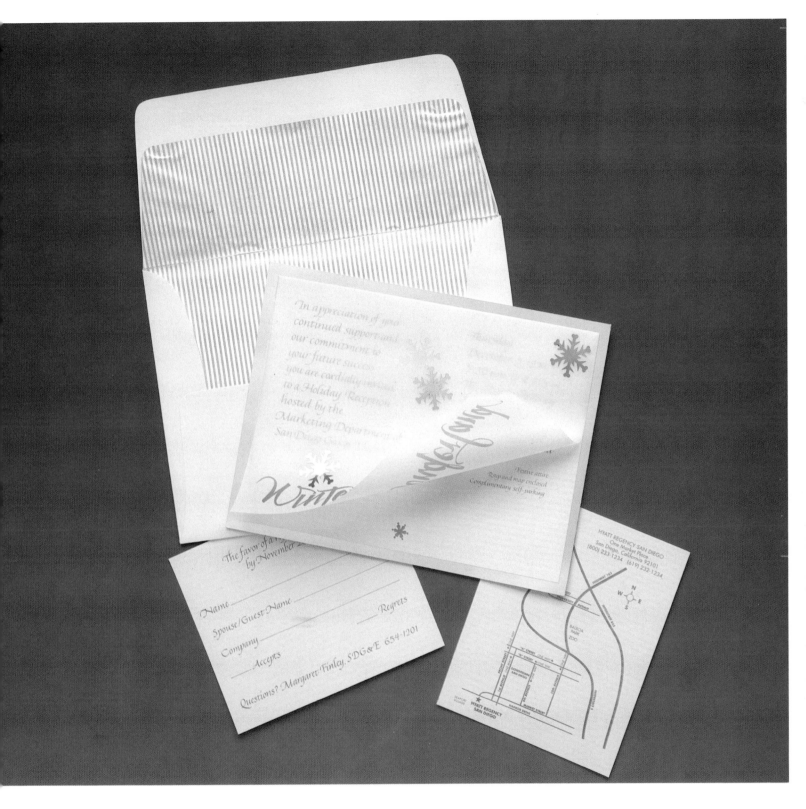

Design Firm **Nancy Stutman**
Art Director/Designer **Nancy Stutman**
Client **San Diego Gas and Electric**
Purpose or Occasion **Holiday party**
Paper/Printing **UV Ultra II/Columns/Offset**
Number of Colors **One**

SDG & E wanted an elegant look to their Winter Wonderland holiday party invitation. UV Ultra II with iridescent snowflakes was used to effectively achieve this goal.

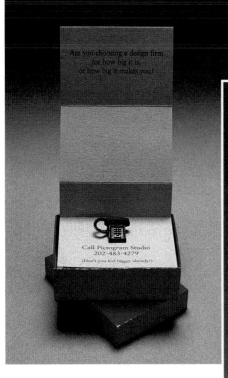

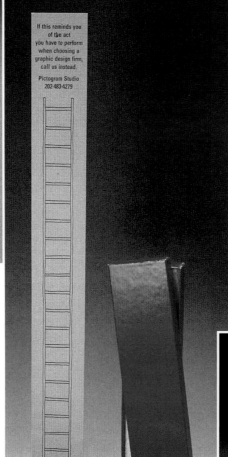

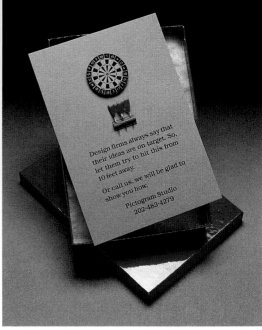

Design Firm **Pictogram Studio**
Art Director **Hien Nguyen**
Designer **Hien Nguyen, Stephanie Hooton**
Client **Pictogram Studio**

Each of the boxes in this promotional series was sent to a prospective client every two to three weeks. "They've really helped us break the ice with new clients," says firm principal Stephanie Hooton.

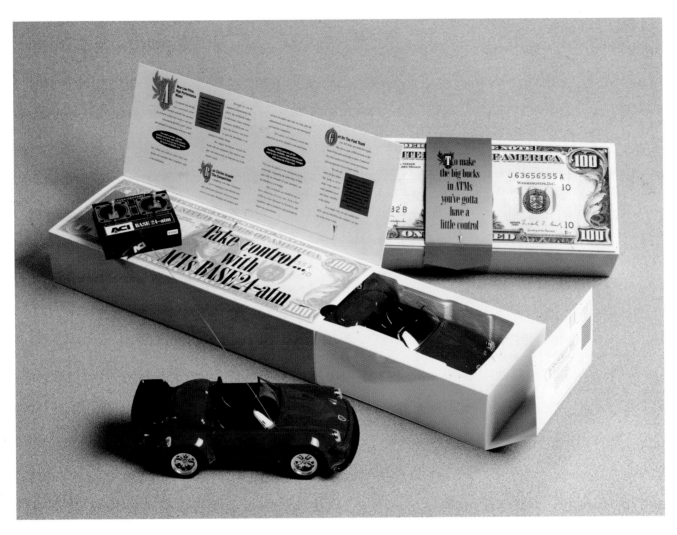

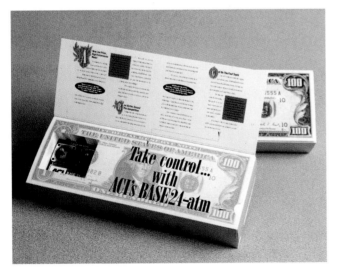

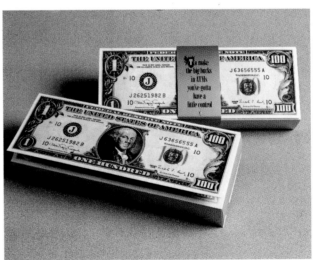

Design Firm **Webster Design Associates Inc.**
Art Director **Dave Webster**
Designers **Dave Webster, Todd Eby**
Illustrator **Todd Eby**
Client **ACI**
Purpose or Occasion **Introduce ACI ATM network**
Paper or Printing **Corporate Image**
Number of Colors **Two**

This promotion was devised to introduce ACI's new ATM network-processing program: Base 24-ATM. The target audience, 40- to 55-year-old male executives, was invited to "take control with Base-24," using the analogy of driving a car. The specialty item offered to reinforce the theme was a toy remote-control Porsche. The piece is displayed in a box designed to look like a stack of bills, an additional attraction for the banking clients.

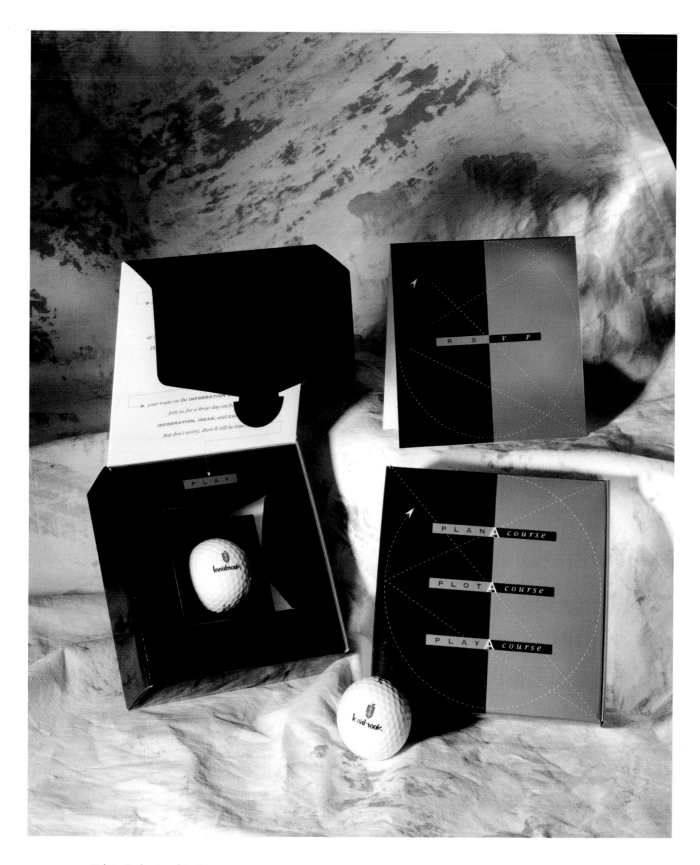

Design Firm **Webster Design Associates Inc.**
Art Director **Dave Webster**
Designers **Todd Eby, Dave Webster**
Illustrator **Todd Eby**
Client **Cable Services Group**
Purpose or Occasion **Invitation to a conference**
Number of Colors **Three plus gold**

This invitation to an executive client conference at a golf resort was designed to arouse interest even before reading the details. The phrase "Plan a course, plot a course, play a course," on the box front was a reference to the resort as well as the conference. The presentation of the golf ball inside the box reinforced the message.

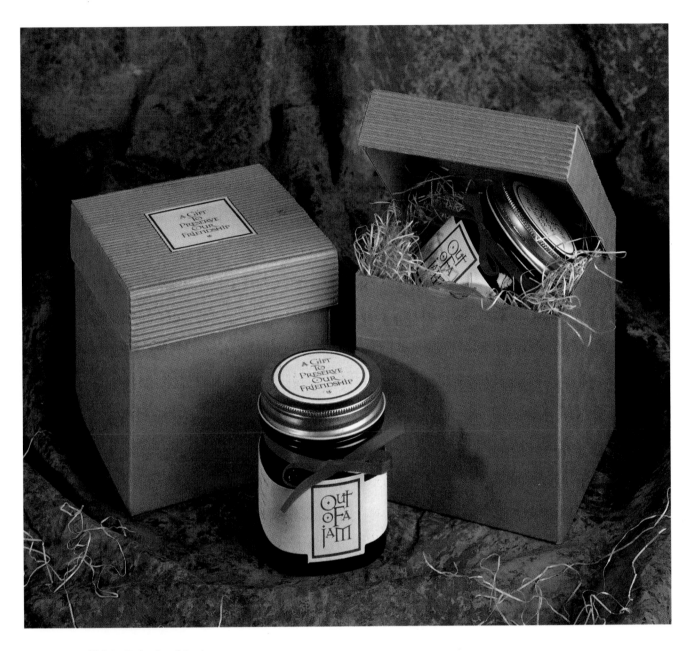

Design Firm **Webster Design Associates, Inc.**
Art Director/Designer **Dave Webster**
Typography **Dave Webster**
Client **Webster Design Associates**
Purpose or Occasion **Holiday mailing**
Paper or Printing **French Speckletone**
Number of Colors **Two**

The name "OutofaJam" was inspired by puns and wordplay associated with the
product, and the idea that getting clients out of graphic quandaries is the design
firm's function. The firm frequently uses this method in promotion and mailings:
making connections between product and copy that are unique, humorous, and
attention grabbing.

GENIUS

IS THE CAPACITY TO SEE TEN THINGS

WHERE THE ORDINARY MAN SEES ONE

AND WHERE THE MAN OF TALENT SEES TWO OR THREE

EZRA POUND

ARTIST'S

ANGLE

INC

Design Firm
EMA Design Inc.
Art Director
Thomas C. Ema
Designers
Thomas C. Ema, Debra Johnson Humphrey
Original Size
10" x 6" (25 cm x 15 cm)
Client
Artist's Angle Inc.
Photographer
Stephen Ramsey
Printing
Offset

These postcards announce and describe specific services provided by Artist's Angle. The designer took the images—taken by several photographers—and laid them out in Macromedia FreeHand.

44

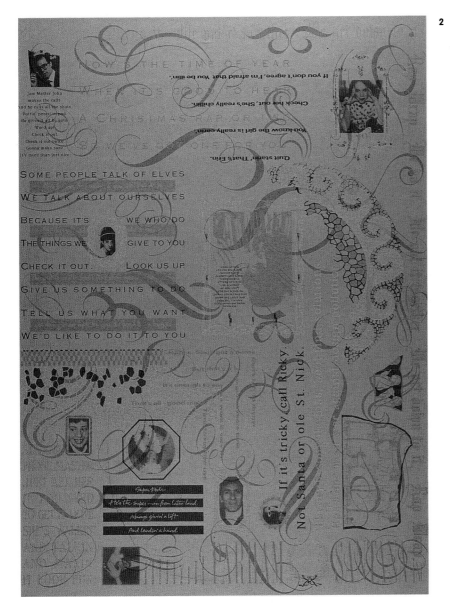

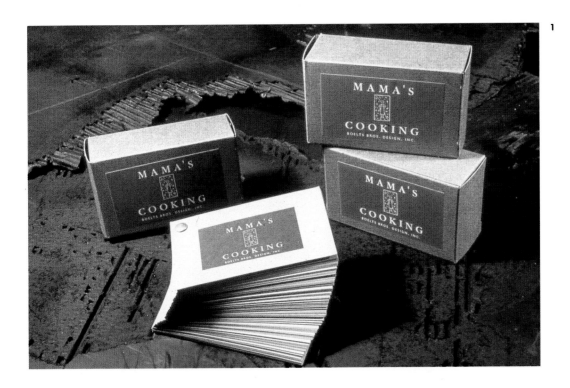

1
Design Firm **Boelts Bros. Design, Inc.**
Art Director/Designer **Eric Boelts, Jackson Boelts, Kerry Stratford**
Client **Boelts Bros. Design, Inc.**

Boelts Bros. offers their mom's great recipes in this holiday gift of a cookbook to prospective and existing clients. "Our mom is a terrific cook and we thought our clients would like her recipes as a holiday gift," says Jackson Boelts, adding that many are family recipes handed down over many generations.

2
Design Firm **Parham Santana**
Art Director **John Parham**
Designer **Maruchi Santana**
Copywriter **Mary Louise Chatel**
Client **Parham Santana**

This "rap wrap" for the holidays sends a clever promotional message to clients. The poster's display in the offices of its recipients brought Parham Santana additional exposure. "The piece gave us a lot of credibility in terms of our youth market exposure and was featured in the AIGA annual," says Maruchi Santana.

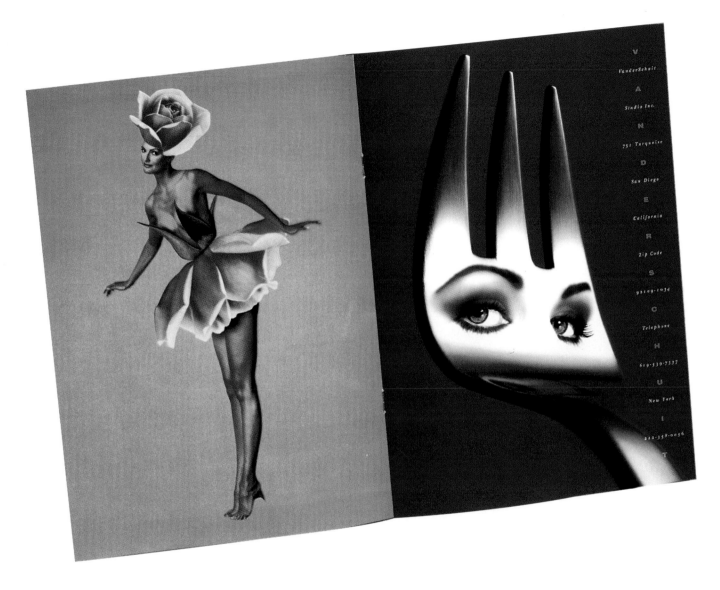

◁ △
Design Firm **Mires Design**
Art Director **Jose Serrano**
Designers **Jose Serrano, Eric Freedman**
Photographer **Carl Vanderschuit**
Client **Vanderschuit Photography**
Purpose or Occasion **Announcement of new photography style**
Number of Colors **Four**

The purpose of this mailer was to showcase a new style of photography in a
fresh way without too much copy. This way, the visuals were able to speak for
themselves.

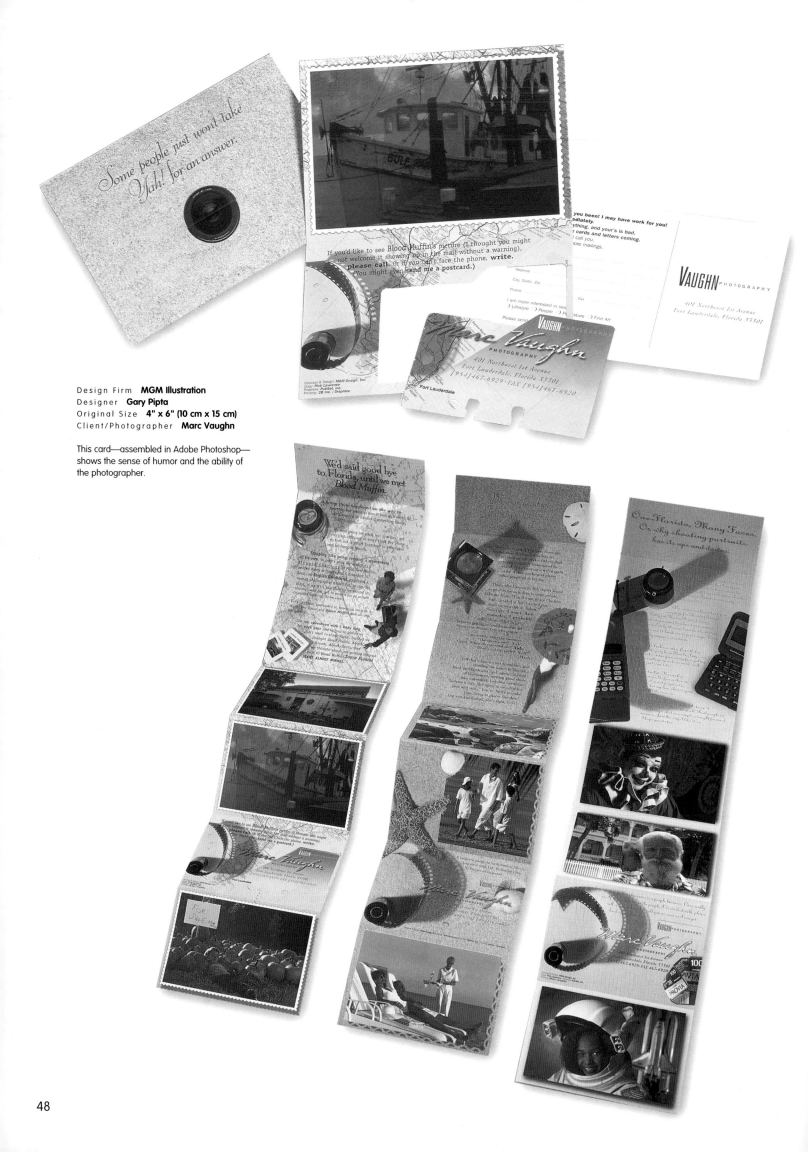

Design Firm MGM Illustration
Designer Gary Pipta
Original Size 4" x 6" (10 cm x 15 cm)
Client/Photographer Marc Vaughn

This card—assembled in Adobe Photoshop—shows the sense of humor and the ability of the photographer.

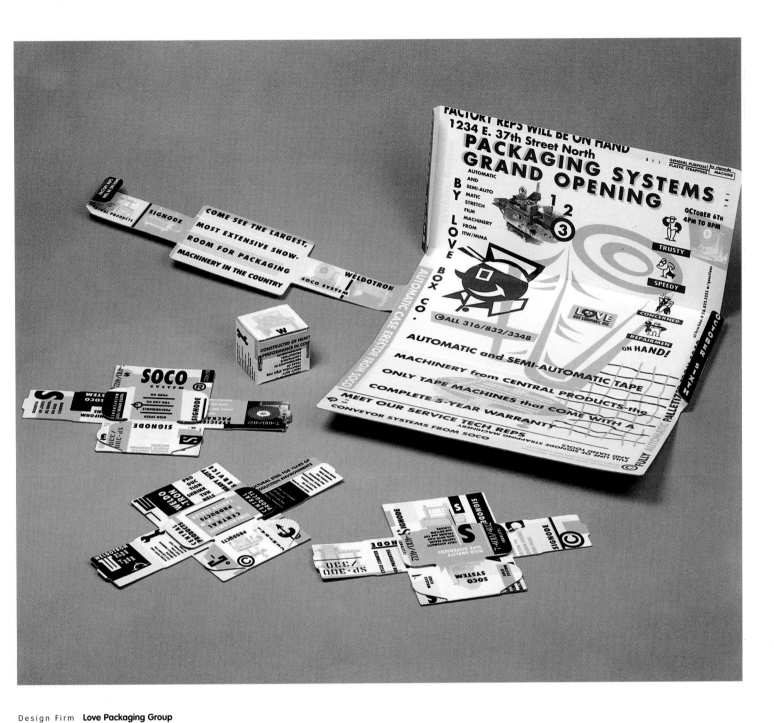

Design Firm **Love Packaging Group**
All Design **Brian Miller**
Client **Love Packaging Group**
Purpose or Occasion **Grand opening invitation**
Paper/Printing **Corrugated/Rand Graphic Products, screen printing**
Number of Colors **Three**

The invitation was manufactured out of corrugated board. The curiosity-reminder pieces inside are four small desktop boxes that each feature a different company with machinery represented at Love Packaging Systems. Photos of machinery at the facility were turned to halftones with a huge dot-screen pattern to allow for screen printing that resembles flexographic Brown-Box printing. Macromedia FreeHand was used for layout and Adobe Photoshop for converting/experimenting with the photo halftones. The flaps of the overpack are perforated, allowing the inside to convert into a poster.

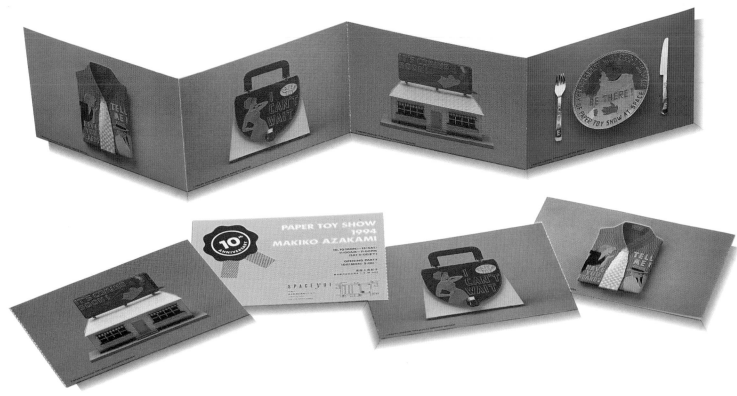

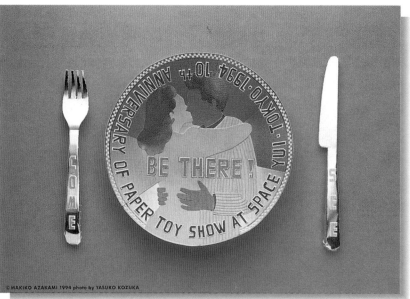

Design Firm **N.G.**
Art Director/Illustrator **Makiko Azakami**
Designer **Kyoko Iida**
Photographer **Haruhiko Tanizaki**
Original Size **4" x 10" (10 cm x 25 cm)**
Printing **4-color offset printing**

These hand-cut objects are formed primarily from Pantone paper, secured with double-sided adhesive tape. The designer creates these three-dimensional "paper toys" as commissioned illustrations, as well as for personal pieces. The designer created this perforated fan-postcard set as an invitation for a one-person exhibition of the designer's work at Space Yui Gallery (Tokyo) in 1994.

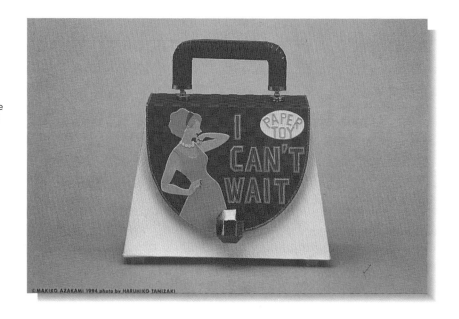

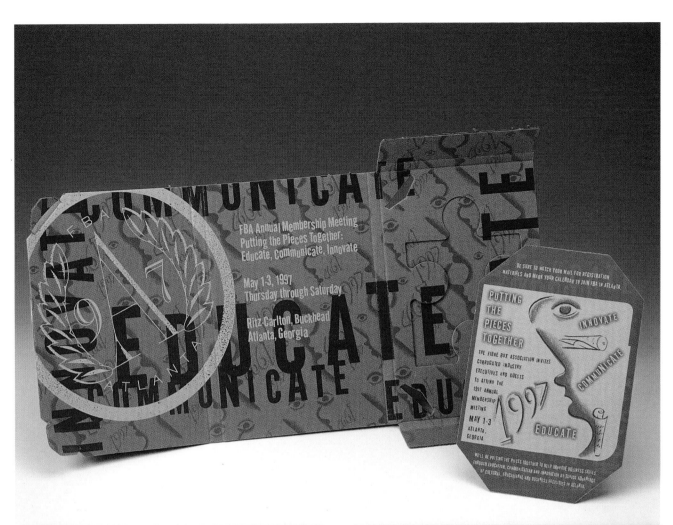

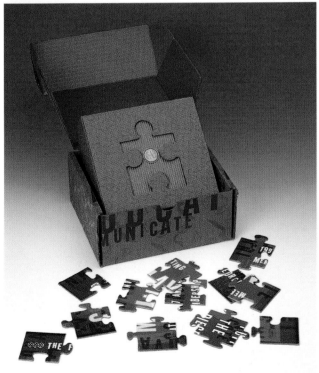

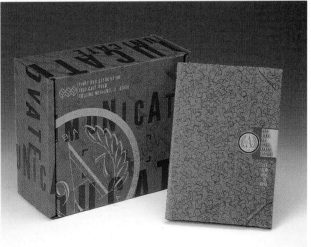

Design Firm **Love Packaging Group**
Art Director **Brian Miller**
Designer/Illustrator **Chris West**
Client **Fibre Box Association**
Purpose or Occasion **1997 FBA Annual Meeting**
Paper/Printing **Corrugated/Rand Graphics, Inc., silkscreen**
Number of Colors **Three**

FBA wanted the design to suggest the theme for the meeting as well as provide
inspiration for people to attend the event. The teaser introduced the puzzle
theme with a removable die-cut puzzle piece that could be redeemed at the
meeting to receive the official program. The puzzle piece actually fits into the
program cover. The single face card was hand-cut to fit the teaser cover. The
circle "A" icon for Atlanta was placed by hand on the back of this single-face
card to be viewed through the opening left by the removed puzzle piece. This
look was repeated in the second mailing, the nested puzzle boxes.

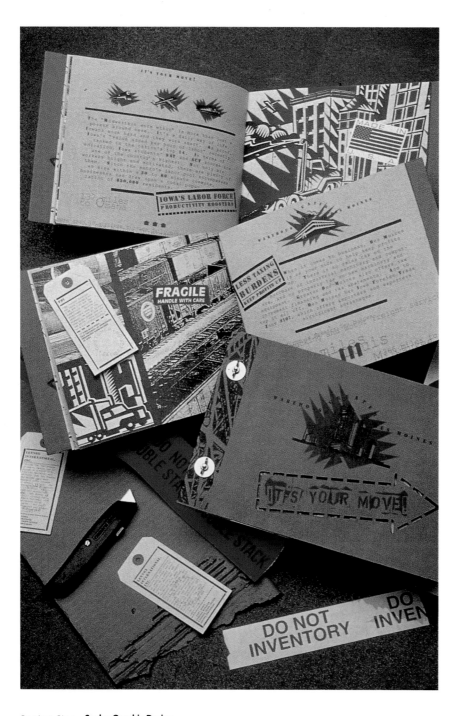

Design Firm **Sayles Graphic Design**
Art Director **John Sayles**
Designers **John Sayles, Jennifer Elliott**
Illustrator **John Sayles**
Client **Greater Des Moines Chamber of Commerce**
Purpose or Occasion **Informational Brochure**
Paper/Printing **Manila tag, Curtis Tuscan Terra, corrugated/Offset, screen-printed**
Number of Colors **Two**

Designed to promote the city's warehouse and distribution potential, the brochure has a corrugated cardboard cover that is bound with bolts and wing nuts. A die-cut arrow surrounds type that tells the recipient that "It's Your Move," while reinforcing the "industrial warehouse" look of the mailing. Inside the brochure, grainy photographs and Sayles' original illustrations are reproduced on manila tagboard. Each spread in the brochure features a colorful label with a different warehousing message. Manila shipping tags are tipped in, featuring different testimonials from different warehouse-company executives. A perforated reply card is also included. The mailer is held closed with "Do Not Inventory" box tape.

(Opposite page)
Design Firm **Janet Hughes and Associates**
Art Director/Designer **Donna Perzel**
Client **Du Pont**

This multicomponent mailer, promoting a museum tour and brunch, was mailed with a gold frame. Those who attended the tour received a print to fit their frame.

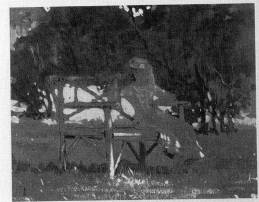

There's a famous museum in San Antonio where a long list of outstanding artists resides.

Kindly accept our invitation to a private tour during the NPRA Meeting in April. You are invited to be the guest of DuPont on Tuesday, April 3 for a special tour and brunch at the distinguished McNay Art Museum in San Antonio.

As your host for the day, we have made all the arrangements for you. A continental breakfast will be served at 9 a.m. in Section C of the Ballroom at the Marriott Rivercenter Hotel. The coach will then depart for the museum at 10 a.m. Brunch will be served in the Sculpture Garden at the conclusion of the viewing and local artist Jay Hester will speak. Arrival back at the hotel will be approximately 2 p.m.

Meet artist Jay Hester, our guest speaker at brunch. A renowned sculptor and painter whose works have been collected and exhibited throughout the South, Jay Hester resides in the scenic Hill Country of Texas. He has sculpted works in a variety of media—from bronze to clay—and has painted in watercolors, acrylics and oils. Most known for his ceramics and oil-paint portraits, this gifted artist will inform and inspire us with his passion for his work.

After your tour, this will frame a fine piece of art. We will be pleased to present you with a gift print from the McNay collection of originals, following your visit to the museum. You may save this frame and use it to display the print at home.

We hope you will be our guest for a day at the McNay. One of the few places you'll find so many great artists' paintings in residence.

Mark your confirmation card and mail it in the enclosed envelope by March 12.

What's the one place where all these great names appear together?

Watercolor on paper
The Mary and Sylvan Lang Collection
Marion Koogler McNay Art Museum
San Antonio, Texas

GIRL ON A GARDEN SEAT
(WOMAN SEATED ON BENCH) 1878

Winslow Homer
American, 1836–1910

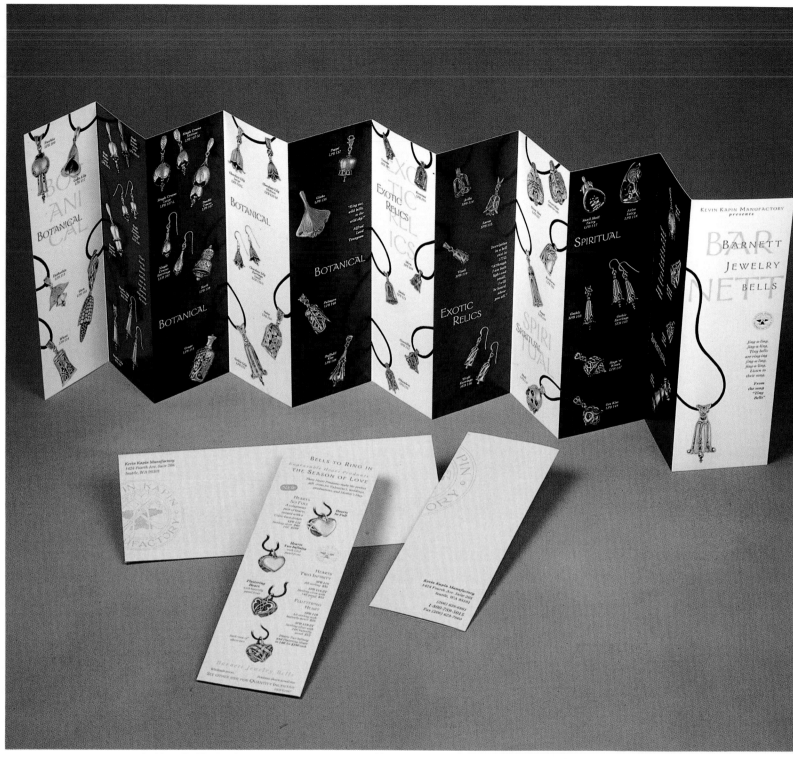

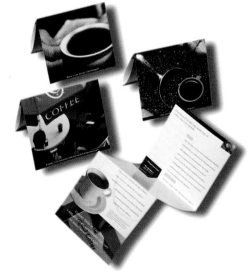

△
Design Firm **Belyea Design Alliance**
Art Director **Patricia Belyea**
Designer **Adrianna Jumping Eagle**
Illustrator **Ron Hansen**
Client **Kevin Kapin Manufacturing**
Purpose or Occasion **Wholesale mailer**
Number of Colors **Four**

All of the jewelry bells were photographed under a dome as well as retouched to remove any reflections. They were reproduced at exact size to show the scale of the product.

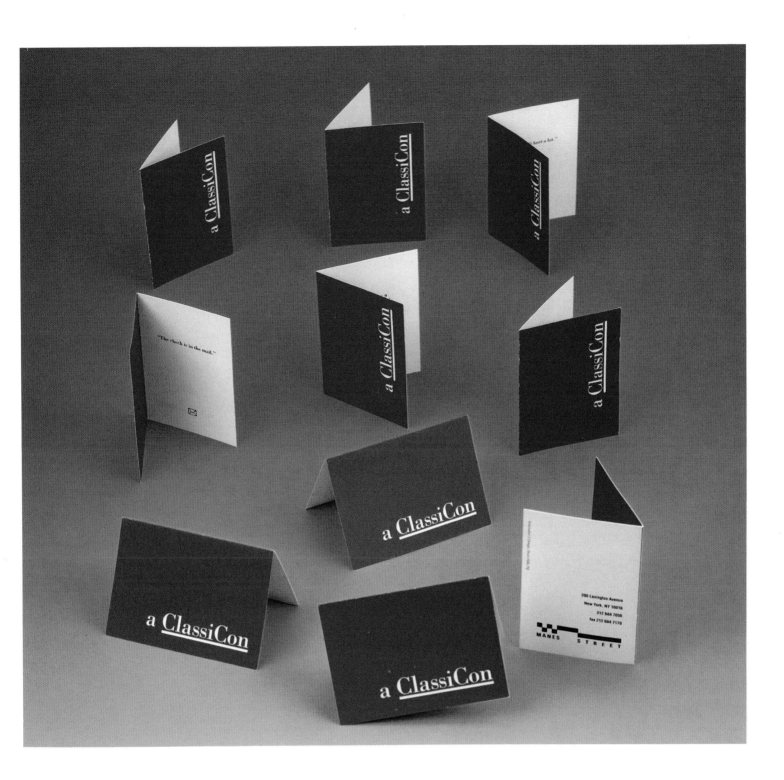

◁

Design Firm **The Focal Group**
Art Director **Paulo Simas**
Designer **Tamara Tom**
Client **Clarinet Communications**
Purpose or Occasion **Customer subscriptions**
Paper/Printing **Centura dull coated 100 lb./Linotext**
Number of Colors **Two**

This project was created using Adobe Illustrator, Adobe Photoshop, and QuarkXPress. The purpose of the piece was to increase customer subscriptions to the client an Internet access provider. Coffee, coasters, and images were given away to help in the campaign's efforts.

△

Design Firm
Toni Schowalter Design
Art Director/Designer
Toni Schowalter
Client
Manes Space
Purpose or Occasion
Promotion
Paper/Printing
65 lb. cover
Number of Colors
Two

The project involved producing ten individual cards that would promote the furniture company's name, Classic Con, by tying into well-known quotes. Each card has a different quote and they were distributed as a series to provide momentum.

Design Firm
Design Guys

Art Director
Steven Sikora

Designer
Richard Boynton

Project
Target cashier triathlon posters

Client
Target

Purpose or Occasion
Promoting improved cashier performance

Software
Adobe Photoshop, Adobe Illustrator, QuarkXpress

Hardware
Macintosh Quadra 950

▶ The Target cashier triathlon was a speed and service program for store cashiers. The series of six posters comprised three teaser posters before the program's introduction and three monthly reminder posters after the program's launch.

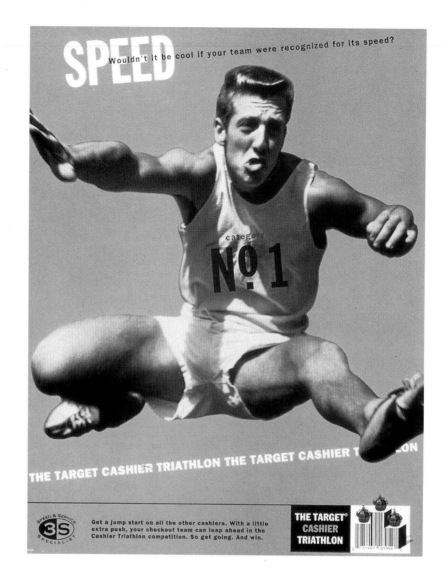

Design Firm
Insight Design Communications

All Design
Sherrie Holdeman, Tracy Holdeman

Project
AIGA Macintosh workshop

Client
AIGA

Purpose or Occasion
Workshop

Software
Macromedia FreeHand, Adobe Photoshop

Hardware
Macintosh 7500

▶ The AIGA "How to do-it-yourself" Macintosh workshop is a twist on the theme of a home workshop — specifically the workshop of the 1950s home handyman as depicted in the many do-it-yourself repair books and encyclopedias of the time. In the design of the AIGA piece, the mission was to make the piece look like it was not done on a computer. The cover is an obscure illustration of a computer. The headline is almost unreadable, and the subheads are incorporated into a piece of blueprint collage that wraps over the fold. All items used for collage purposes came from old how-to books. For the finishing touch, torn pieces of duct tape were used as a closure tab.

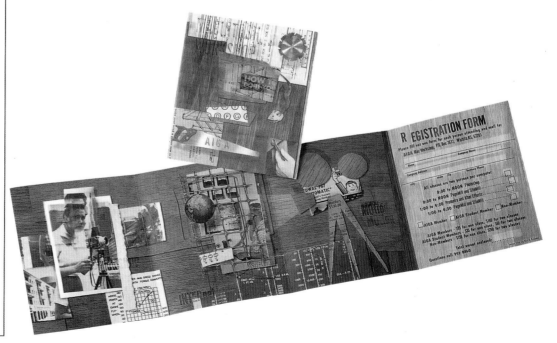

Event

Design Firm
Jim Lange Design

Art Director
Tom O'Grady

Designer/Illustrator
Jim Lange

Project
NBA All-Star Weekend logo

Client
NBA

Purpose or Occasion
NBA All-Star Weekend

Software
Adobe Illustrator

Hardware
Macintosh

▶ The main elements of this logo were pulled from various aspects of the weekend's events—player's uniforms, audience banners, and floor detailing.

Event

Design Firm
Insight Design Communications

All Design
Sherrie Holdeman, Tracy Holdeman

Project
Special-event material

Client
The Mid-Kansas Clubs of Printing House Craftsmen

Purpose or Occasion
Craftsman Club printing competition

Software
Macromedia FreeHand, Adobe Photoshop

Hardware
Macintosh 7500

▶ The print material used to promote the client's event include: direct-mail poster/call for entries, invitations, awards, and a program. With the theme "It's the People that Make the Difference," the background simulates a press sheet that explains offset printing. The poster was left uncropped to show the printer's color bars and crop marks. The make-ready look of overprinted inks in the hand and lower-left corner was created in FreeHand and Photoshop and the type was set in FreeHand and pasted into Photoshop. The solid type was converted into halftone dots of various degrees by changing the mode from grayscale to bitmap where the dot size can be selected by number.

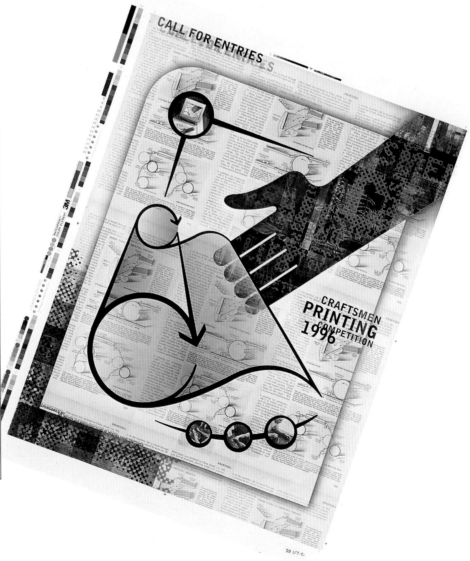

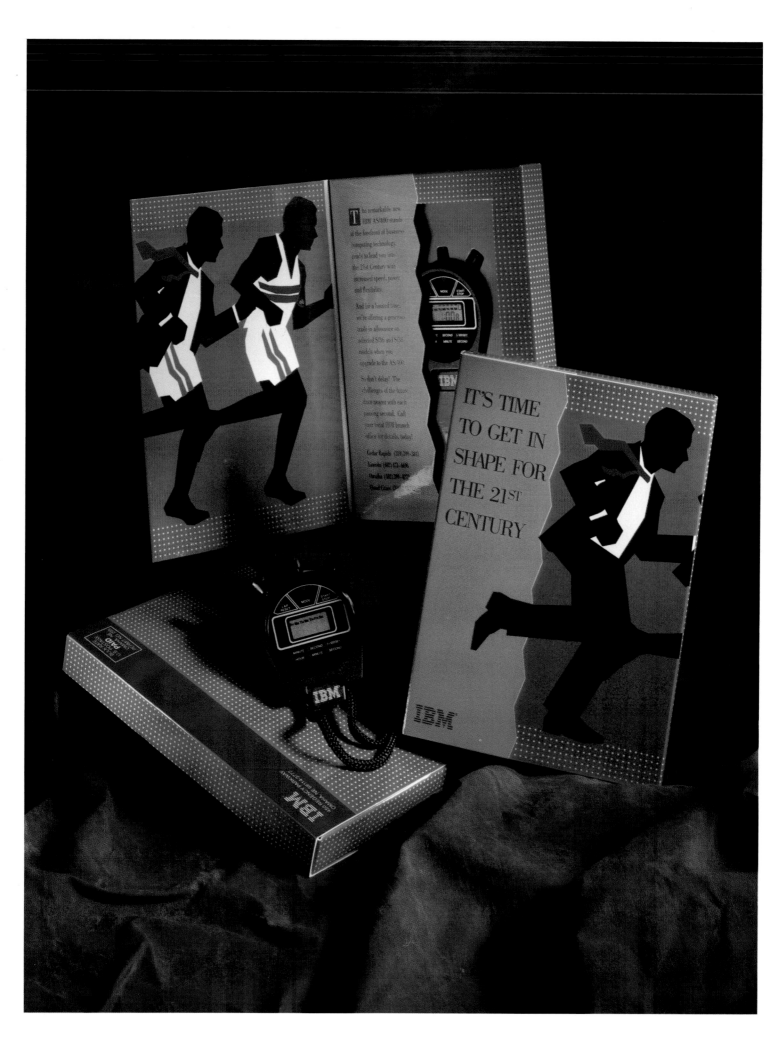

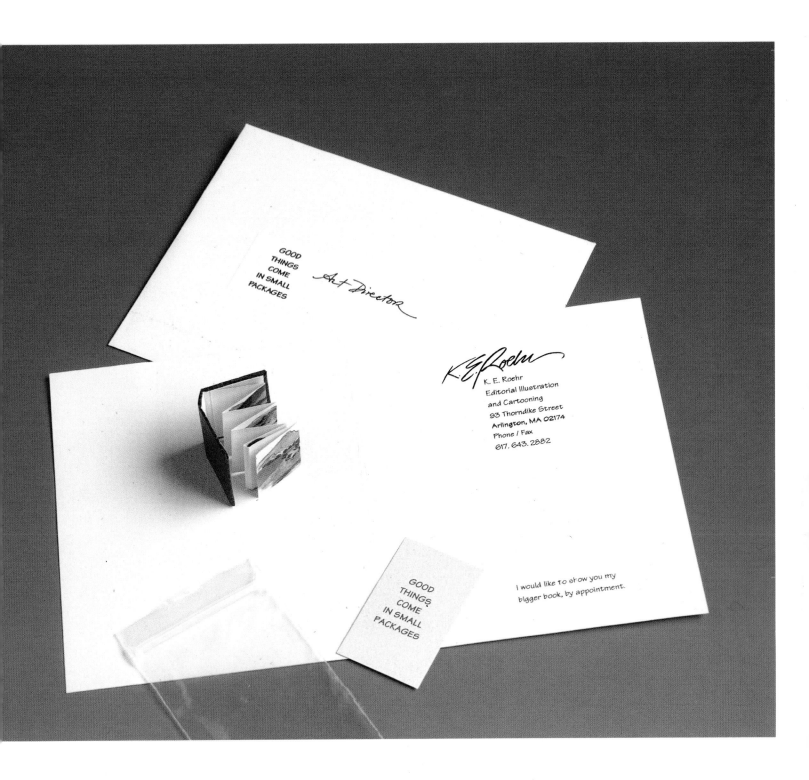

GOOD
THINGS
COME
IN SMALL
PACKAGES

Art Director

K. E. Roehr
Editorial Illustration
and Cartooning
93 Thorndike Street
Arlington, MA 02174
Phone / Fax
617. 643. 2882

GOOD
THINGS
COME
IN SMALL
PACKAGES

I would like to show you my
bigger book, by appointment.

Design Firm **K. E. Roehr Design and Illustration**
All Design **K. E. Roehr**
Client **K. E. Roehr**
Purpose or Occasion **Self-promotion illustration piece**
Paper/Printing **Various/hand-made books**
Number of Colors **Four-color insert**

This illustration includes a handmade miniature book produced
with the intent of giving prospective clients something precious and
unique that would remain in sight rather than being filed.

(opposite page)
Design Firm **Webster Design Associates, Inc.**
Art Director/Designer **Dave Webster**
Illustrator **Todd Eby**
Client **IBM**
Purpose or Occasion **Promote new computer line**
Paper or Printing **Corporate Image**
Number of Colors **Four PMS**

To promote IBM's new line of computer products, a limited-time
offer for upgrading was introduced with a stopwatch. The watch
reinforced the message of the offer's limited-time nature, as well as
its timeliness. The heading on the front of the box and the graphic
metamorphosis of the corporate figure complement the theme,
unifying the message and the promotional item.

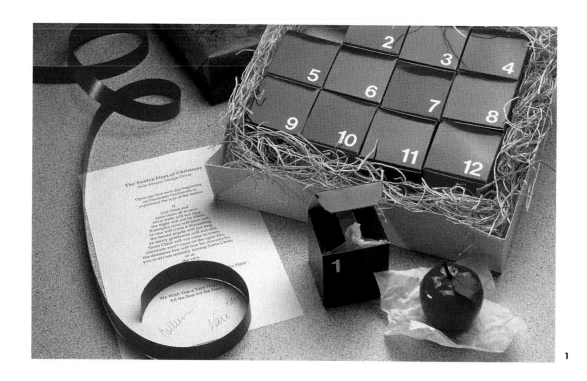

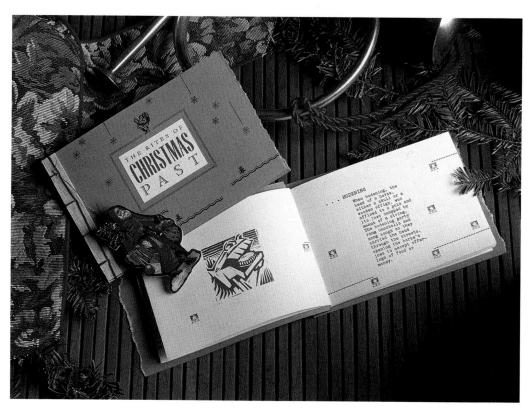

1
Design Firm **Abrams Design Group**
Art Director **Colleen Abrams**
Designer **Colleen Abrams, Kari Perin, Kay Watanabe**
Client **Abrams Design Group**

As a holiday promotional piece and thank-you gift, Abrams Design sent a carton of color-coordinated surprise boxes to its clients—one box for each of the 12 days of Christmas. Each box contained a holiday ornament, confection, or keepsake.

2
Design Firm **Rickabaugh Graphics**
Art Director **Eric Rickabaugh**
Designer **Michael Tennyson Smith**
Illustrator **Michael Tennyson Smith**
Client **Rickabaugh Graphics**

For a charming, hand-crafted look, this book of holiday lore was produced entirely on a letterpress and bound by hand. It was sent to clients, vendors, and friends as a seasonal greeting.

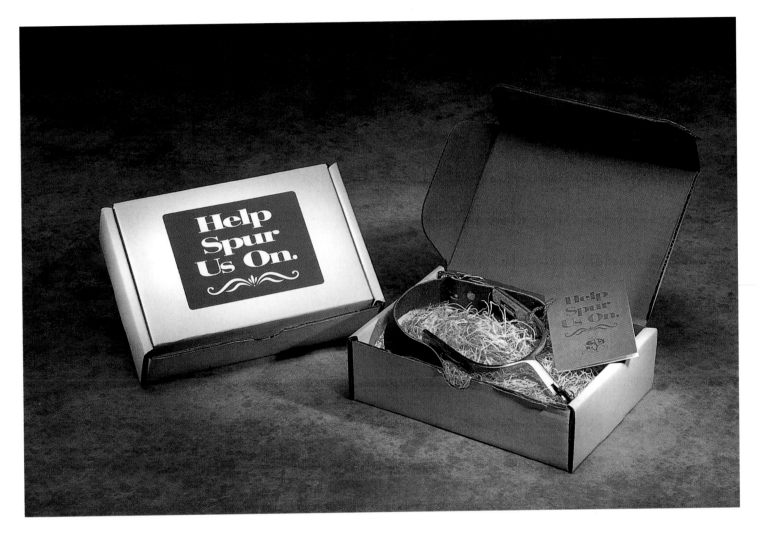

Design Firm **The Wyatt Group**
Art Director **James Ward**
Copywriter **Mike Maccioli**
Creative Directors **Mark Wyatt, Mike Maccioli**
Client **Homeless Outreach Medical Services (HOMES)**
Purpose or Occasion **Fund raiser**
Number of Colors **Two**

HOMES is a non-profit program of Parkland Health & Hospital Systems that
provides medical care to thousands of homeless women and children in Dallas.
To help kick off this year's fund-raising efforts, a party was held at a Dallas
country-and-western nightclub. In keeping with the western motif, spurs were
sent to the guest list encouraging the recipients to "Help Spur Us On." The event
was a rousing success.

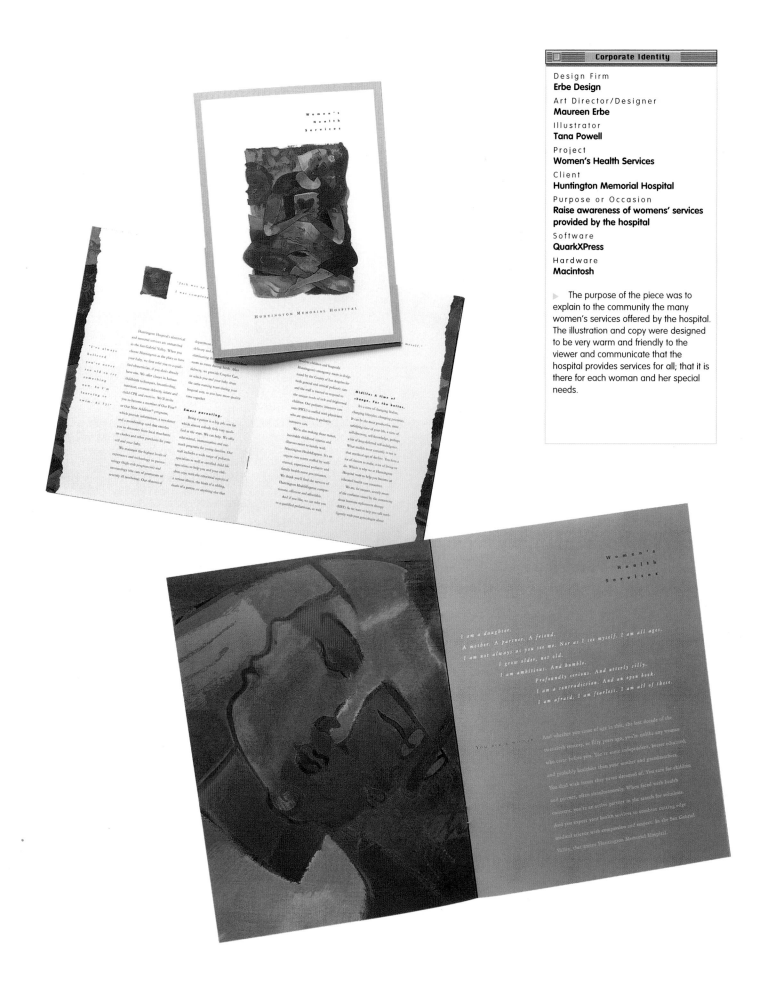

Corporate Identity

Design Firm
Erbe Design

Art Director/Designer
Maureen Erbe

Illustrator
Tana Powell

Project
Women's Health Services

Client
Huntington Memorial Hospital

Purpose or Occasion
Raise awareness of womens' services provided by the hospital

Software
QuarkXPress

Hardware
Macintosh

▶ The purpose of the piece was to explain to the community the many women's services offered by the hospital. The illustration and copy were designed to be very warm and friendly to the viewer and communicate that the hospital provides services for all; that it is there for each woman and her special needs.

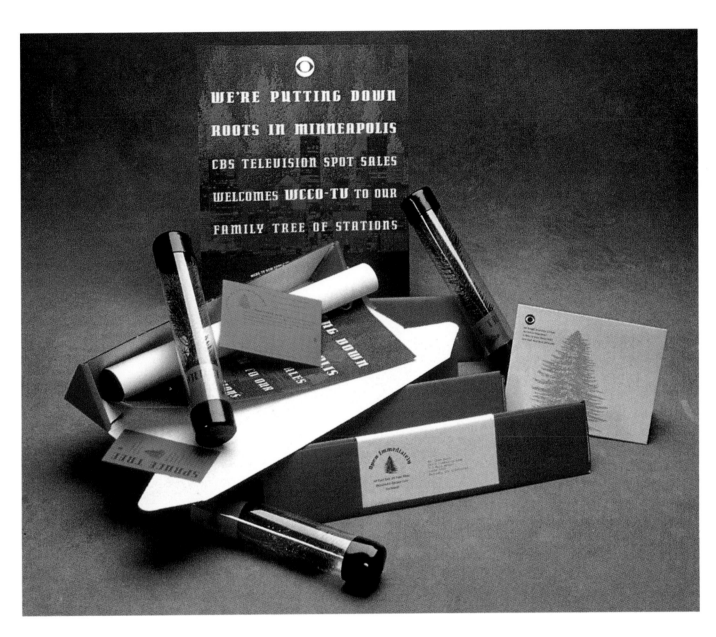

Design Firm **Toni Schowalter Design**
Art Director/Designer **Toni Schowalter**
Client **CBS Television**
Purpose or Occasion **Promotion for new affiliate**
Paper/Printing **Quest Recycled with soy inks**
Number of Colors **Two PMS**

This CBS television Minneapolis announcement was targeted to media buyers; it announces a change in ownership of a Minneapolis TV station. A sweepstakes offer helped to initiate a response. Playing on the theme of growth, the mailing included spruce tree saplings that could be planted. The pieces were sent in a brown, corrugated, triangular box.

Design Firm
Hornall Anderson Design Works

Art Director
Jack Anderson

Designers
**Jack Anderson, John Anicker,
Margaret Long**

Project
Corbis software packaging

Client
Corbis Corporation

Purpose or Occasion
Product packaging

Software
Macromedia FreeHand, Adobe Photoshop

Hardware
Macintosh

▶ The client's software packages
needed to portray their contents and
stand out against the competition. Easily
recognizable images taken from the
Corbis archive are included on the front
of the packages, and are not cluttered,
so they remain recognizable when
reduced for use in a catalog or brochure.

Design Firm **Ads To Go Inc.**
Art Director/Illustrator **Gary Grasmoen**
Designer **Laura Kaplan**
Original Size **6" x 4" (15 cm x 10 cm)**
Client **Tom Schmidt's Urban Retreat**
Printing **1-color**

To promote special spa services for Mothers' Day gift-giving, the client wanted to attract attention in a fun, off-beat manner; the business resides in a somewhat upscale but very trendy area. The price promotion was necessary, but executing it in a unique way grabs attention. The art is a photo of Grandma, superimposed with curlers. This very effective promotion generated more than fifteen percent response.

Design Firm **Belyea Design Alliance**
Art Director/Designer **Tim Ruszel**
Photographers **Michele Barnes, Terry Reed**
Original Size **5 1/2" x 9" (14 cm x 23 cm)**
Client **Princess Tours**
Purpose/Occasion **Valentine Cruise: Love Boat**

Laid out in QuarkXPress, this postcard features logos and photos built and manipulated in Adobe Illustrator and Photoshop. Its purpose was to entice people to book early Alaska cruises at a special discounted rate.

IF YOUR MOTHER EVER EMBARRASSED YOU IN FRONT OF YOUR FRIENDS WITH A FRUMPY HOUSEDRESS, NO MAKEUP & A BUNCH OF CURLERS, GIVE HER A DAY SHE'LL NEVER FORGET

MOTHER'S DAY SPA RETREAT $89.

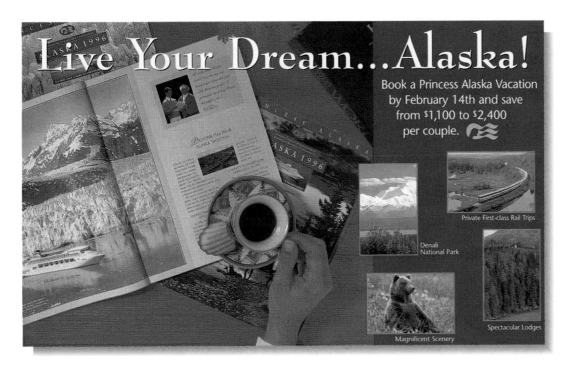

Live Your Dream...Alaska!

Book a Princess Alaska Vacation by February 14th and save from $1,100 to $2,400 per couple.

Private First-class Rail Trips

Denali National Park

Magnificent Scenery

Spectacular Lodges

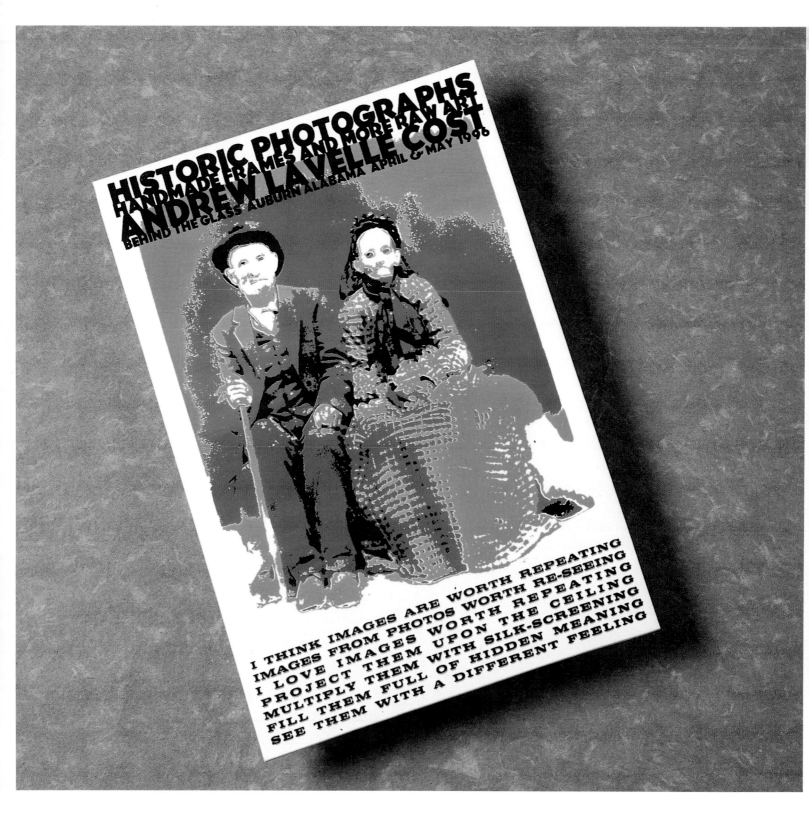

Design Firm **Standard Deluxe, Inc.**
Designer/Illustrator **Andrew Cost**
Purpose or Occasion **Self-promotional poster**
Paper/Printing **Hand silk-screened**
Number of Colors **Three**

The image was created with posterized separations of an antique photo using
Adobe Illustrator; the typesetting was done in Illustrator also. Each flyer was
unique due to the manipulation of inks while printing. A variety of papers were
used as well.

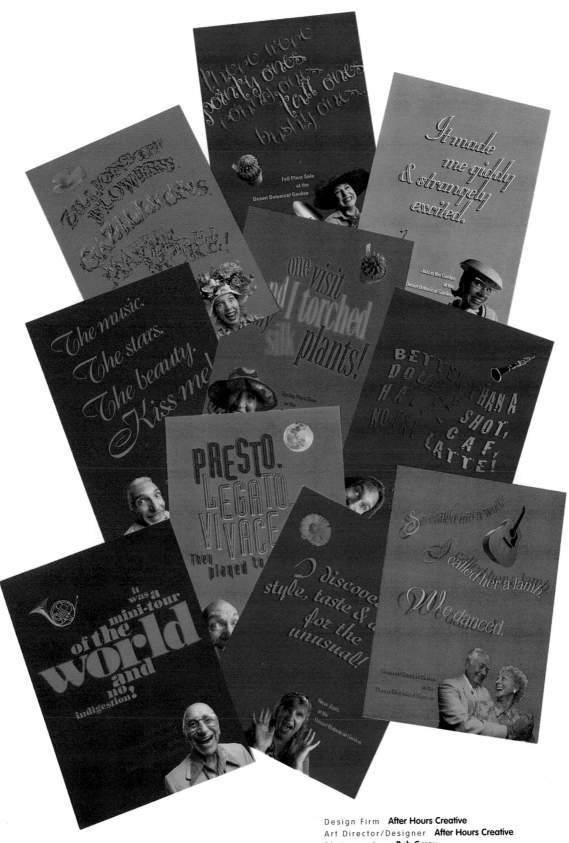

Design Firm **After Hours Creative**
Art Director/Designer **After Hours Creative**
Photographer **Bob Carey**
Client **Desert Botanical Garden**
Number of Colors **Four**

These postcards were used to increase attendance at a variety of special events held by the client. Over the past three years, the postcards have increased attendance by as much as 100% and resulted in more than $100,000 in additional funds for the garden.

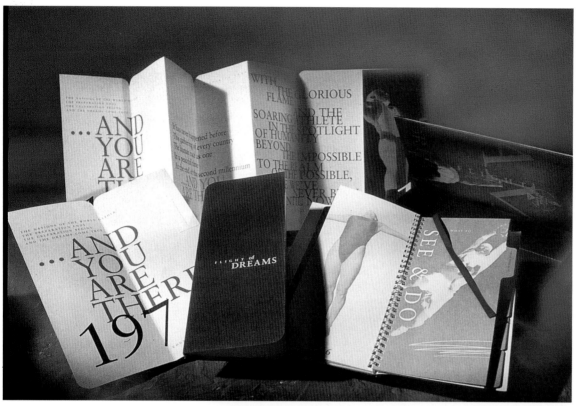

Event

Design Firm
Copeland Hirthler Design and Communications

Creative Directors
Brad Copeland, George Hirthler

Art Director/2D Designer
David Butler

Project
Delta Olympic invitation package

Client
Delta Airlines

▶ This package served as a VIP invitation to guests of Delta for the 1996 Olympic Games. The client wanted a formal announcement/invitation that would not appear too extravagant. The two-color pieces were developed in QuarkXPress and produced on a limited budget using a variety of papers and printers.

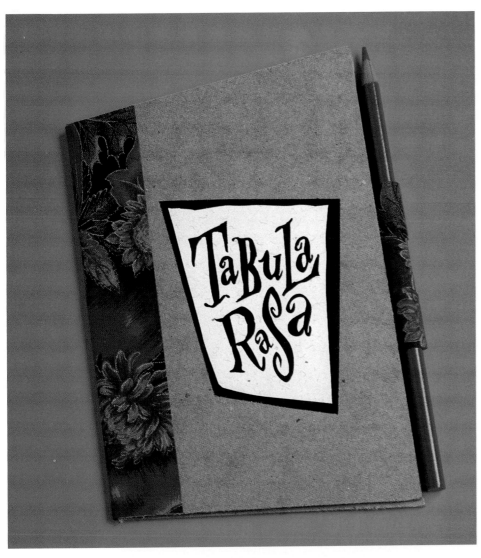

Design Firm
W design, Inc.
Art Director
Alan Wallner
Designer
Christopher Marble
Client
W design
Purpose or Occasion
New Year's self-promotion
Paper/Printing
Davey board/Laser printer
Number of Colors
One

As a company, W design decided to put together a unique self-promotion that would involve all members of the staff. Six hundred Tabula Rasa books were assembled over a two-week span. It proved to be truly a labor of love, but the final effect was well worth it.

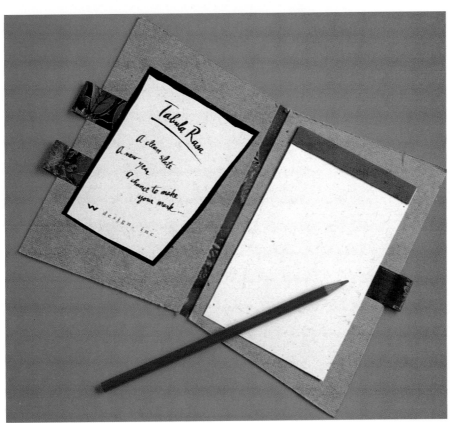

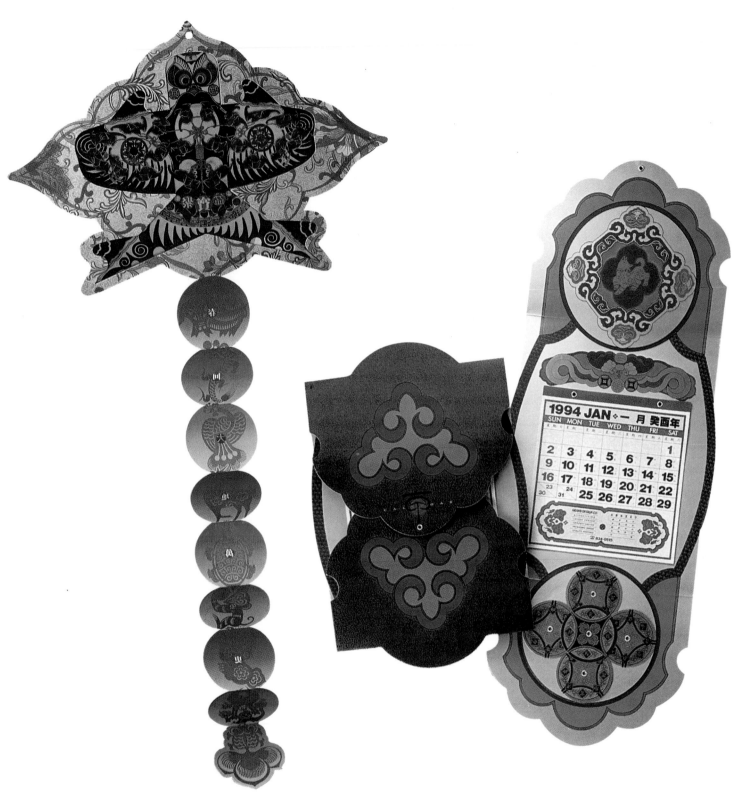

△
Design Firm **Grand Design Company**
Art Director **Grand So**
Designers **Grand So, Raymond Au, Rex Lee, Candy Chan**
Illustrators **Grand So, Rex Lee**
Client **Grand Design Company**
Purpose or Occasion **Chinese New Year Card '95**
Paper/Printing **Fancy paper/Offset, die-cut**

The 1995 Chinese New-Year Card was a kite representing the wish that the prosperity of the business would parallel the kite's upward rise.

△
Design Firm **Grand Design Company**
Art Director **Grand So**
Designers **Grand So, Raymond Au, Candy Chan**
Illustrator **Grand So**
Client **Grand Design Company**
Purpose or Occasion **1994 Grand Design Calendar**
Paper/Printing **Offset, Die-cut**
Number of Colors **Hot Golden Stamping**

The concept, derived from a Chinese luck symbol "yue yee", wishes everyone good luck and a smooth and prosperous 1994.

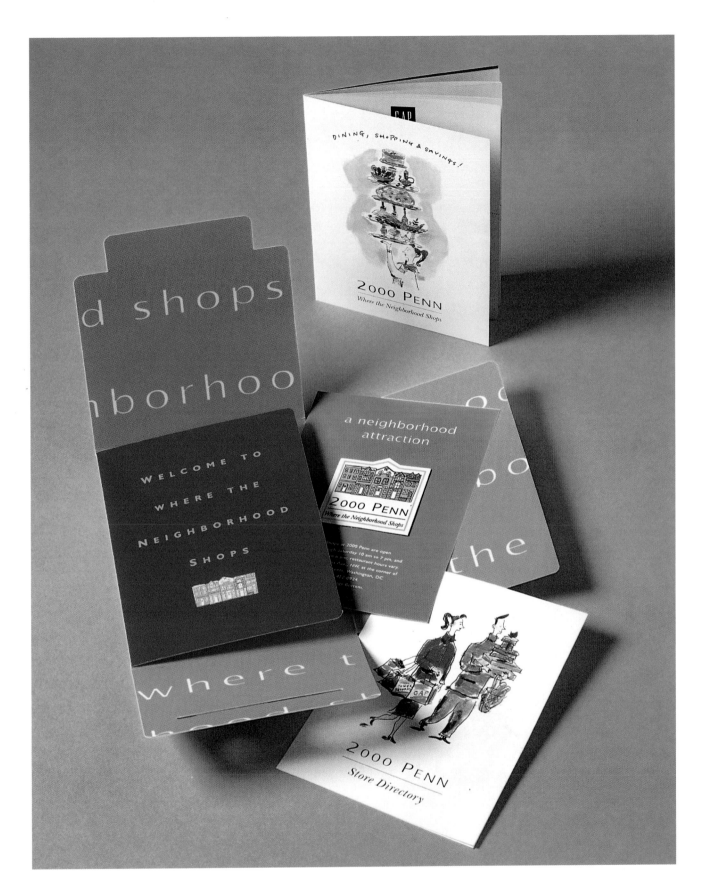

Design Firm **Grafik Communications, Ltd.**
Art Director **Judy Kirpich**
Designer **Gregg Glaviano**
Illustrator **Diane Bigda**
Client **LaSalle Partners**
Purpose or Occasion **Gift for shoppers**
Paper/Printing **Coated lustro board 12 pt./Prisma Graphics Printing Corp. of America**
Number of Colors **Four**

This 2000 Penn Carrier serves as a premium gift for shoppers and includes a directory, magnet, and coupons.

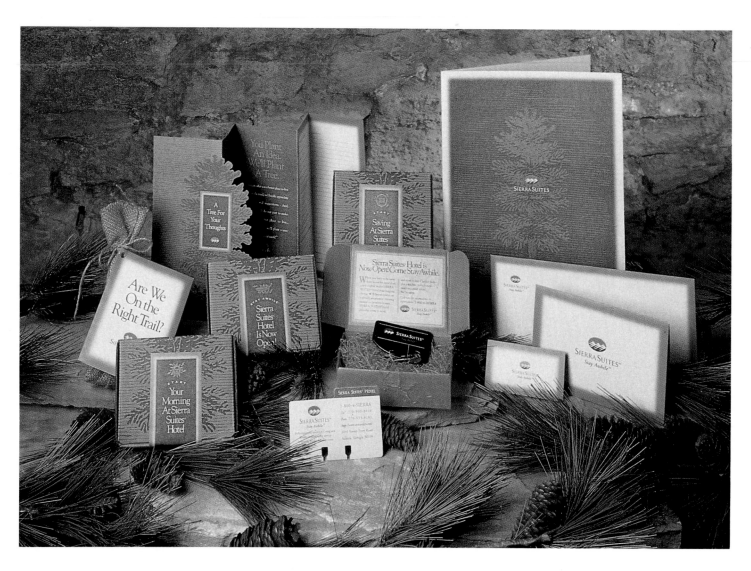

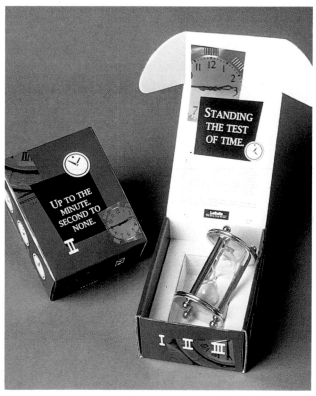

△

Design Firm **Greteman Group**
Art Directors **Sonia Greteman, James Strange**
Designers **Sonia Greteman, James Strange, Craig Tomson**
Illustrators **James Strange, Craig Tomson**
Client **Sierra Suites**
Purpose or Occasion **Direct mail for specific hotels**
Paper/Printing **Passport/Offset**
Number of Colors **Two**

The direct mail campaign included various boxes with items for office use. It was targeted to the busy, corporate executive. A metallic copper with a dark green gave the pieces a natural rich feel. All art was created in Macromedia FreeHand; the woodcut tree illustration was silk-screened onto the box.

◁

Design Firm **Sayles Graphic Design**
Art Director **John Sayles**
Designers **John Sayles, Jennifer Elliott**
Illustrator **John Sayles**
Client **LaSalle National Bank**
Purpose or Occasion **Promotional mailer**
Paper/Printing **Artcraft Fortune Gloss 80 lb. text/Offset**
Number of Colors **Two**

A new promotion for LaSalle National Bank of Chicago has something everyone can use—a little more time—in the shape of a custom hourglass enclosed in the mailing. Dramatic duotone photographs of timepieces are printed with metallic inks. The time theme is reinforced with appropriate graphics—clocks, sundials, watches—and copy that reads "Up To The Minute—Second To None." Inside the corrugated box, a custom tray holds the gold hourglass etched with the client's logo.

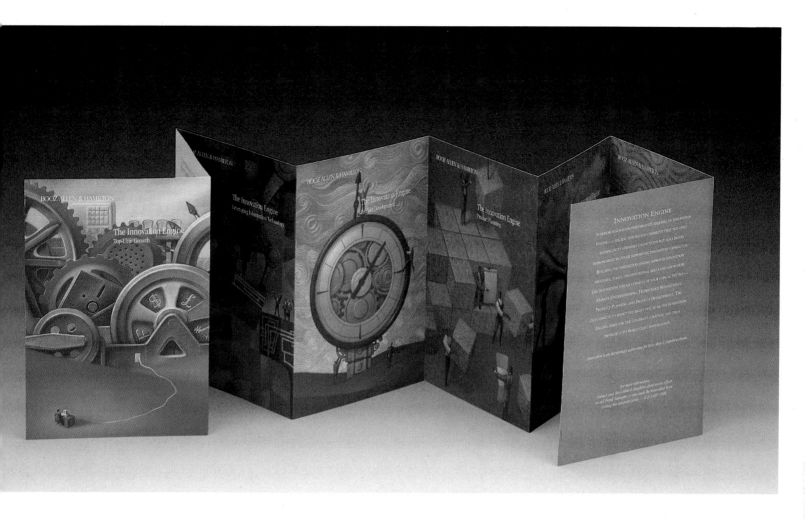

Design Firm
Metropolis Corporation

Creative Director
Denise Davis

Designers
Lisa DiMaio,
Craig Des Roberts

Client
Booz, Allen and Hamilton, Inc.

Purpose or Occasion
Explaining innovation engine

Paper/Printing
Hammermill Regalia

Number of Colors
Five

A series of brochures created to explain Booz, Allen and Hamilton's strategy of creating world class performance through an innovation engine. Building the innovation engine improves innovation processes, tools, organizational skills, and know-how.

Design Firm
Lorraine Williams Illustration

All Design
Lorraine Williams

Client
Lorraine Williams Illustration

Purpose or Occasion
Self-promotion

Paper/Printing
Offset

Number of Colors
Four

This postcard is one in a series of self-promotional cards sent quarterly to various art directors to increase awareness. The mixed-media piece, entitled "Nevermind," was created using dyes, pastels, and watercolor pencil and was sent as a June mailing.

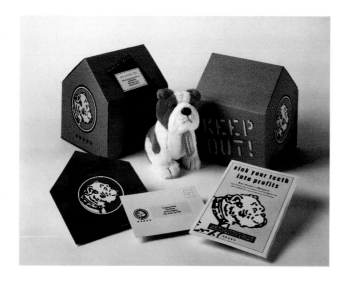

Design Firm **Webster Design Associates, Inc.**
Art Director **Dave Webster**
Designers **Julie Findley, Dave Webster**
Illustrator **Julie Findley**
Client **Inacom**
Purpose or Occasion **Promote Network General Sniffer**
Paper or Printing **Richardson Printing**
Number of Colors **Two**

Network General Sniffer is a network protocol analyzer that is able to detect network problems and allow technicians to make repairs and keep a system running at peak efficiency. The goal of direct mail promotion was to develop product awareness and persuade computer dealers to participate in a company-sponsored rental plan.

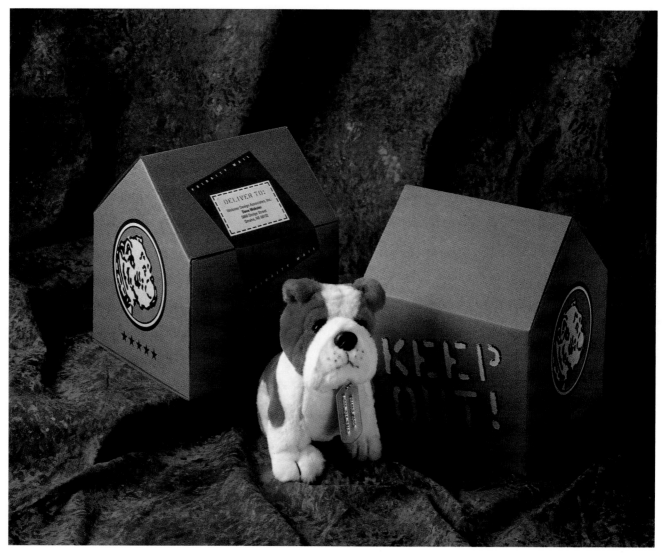

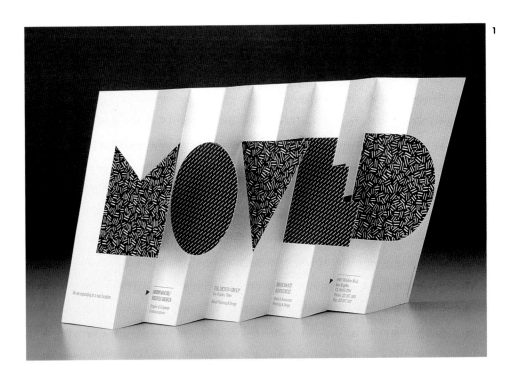

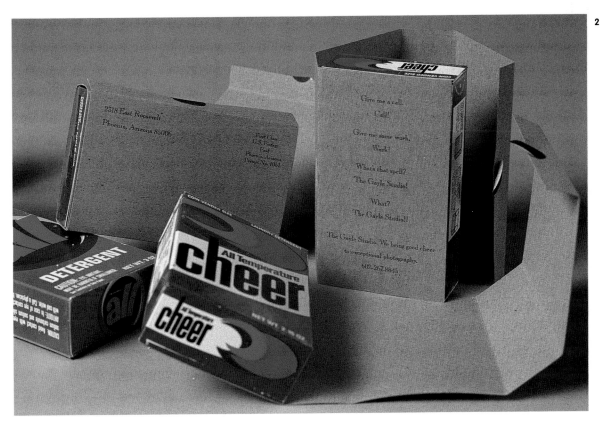

1
Design Firm **Shimokochi/Reeves**
Art Director/Designer **Mamoru Shimokochi, Anne Reeves**
Client **Shimokochi/Reeves**

A move to a new studio presents an opportunity for a promotional mailing. This piece's accordian folds and unique graphics encourage additional exposure as a stand-up display. "We've won numerous awards with it," says firm principal Anne Reeves, citing additional promotional mileage this recognition brought.

2
Design Firm **Richardson or Richardson**
Art Director/Designer **Debi Young Mees**
Copywriters **Valerie Richardson, Debi Young Mees**
Client **Rick Gayle Studio Inc.**

A message of holiday "Cheer" is literally depicted in this memorable promotion for a well-known photographer. "We wanted to promote him in a different way," says firm principal Forrest Richardson, who says this mailing stood out from the more mundane "portfolio" pieces photographers typically send out.

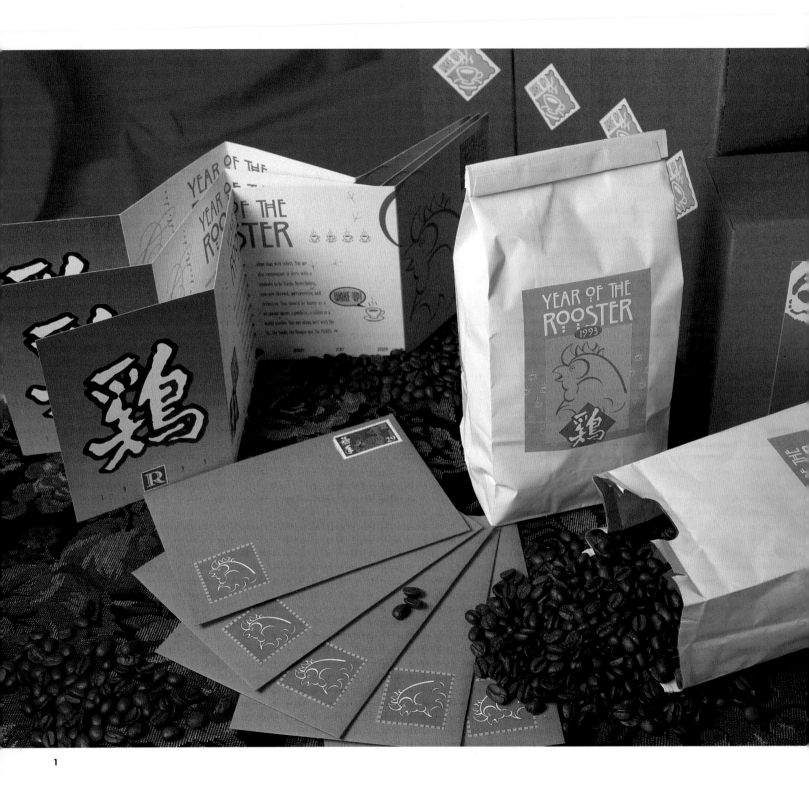

1

Design Firm **Pandamonium Designs**
Art Director **Raymond Yu**
Designers **Raymond Yu, Erin Kroninger**
Photographer **Steven H. Lee**
Client **Pandamonium Designs**

This well-coordinated promotional mailing, consisting of custom-packaged coffee, a greeting card, and special shipping boxes and labels, celebrates the Chinese Zodiac's Year of the Rooster. "We picked up a few clients and additional business from current ones as a result of this mailing," says firm principal Raymond Yu.

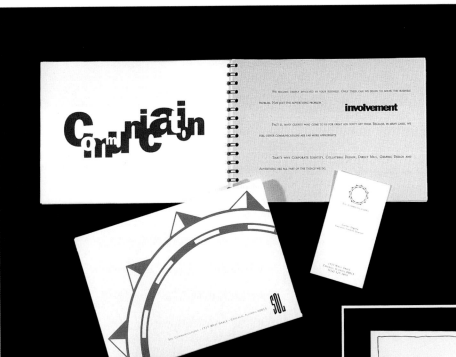

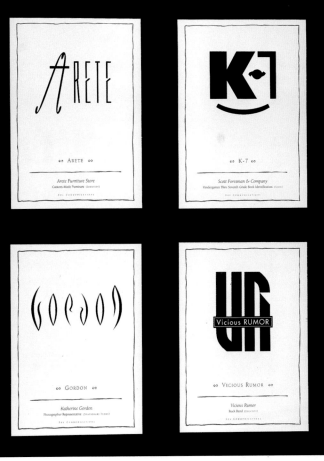

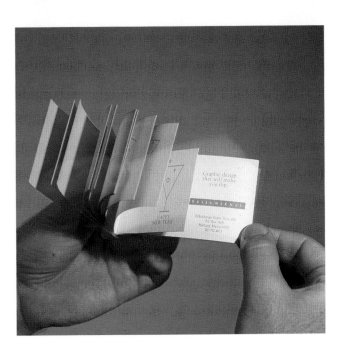

2

3

2
Design Firm **Designsense**
Designer **Dan Howard**
Client **Designsense**

Sent to clients and prospects as a holiday greeting, this animated, hand-assembled flip book shows the metamorphasis of a simple line sketch of a Christmas tree (at the opening) into a New Year's champagne glass (at the end). "People kept it," says designer Dan Howard. "It keeps our name in front of our clients."

3
Design Firm **Segura Inc.**
Art Director/Designer **Carlos Segura**
Illustrator **Carlos Segura**
Client **Segura Inc.**

This self-promotion artfully packages a variety of logo jobs. The distinctive outer mailer echoes the simplicity of its contents yet is eye-catching enough to catch a recipient's attention. "This promotional package put us on the map and helped me establish my business," says firm principal Carlos Segura.

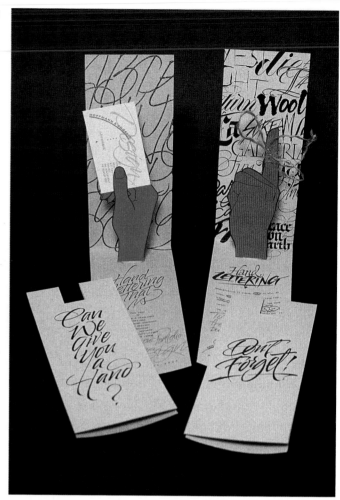

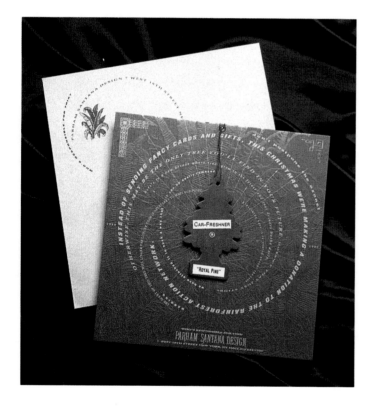

1

Design Firm **Parham Santana**
Art Directors **Maruchi Santana, John Parham**
Designer **Maruchi Santana**
Copywriter **Mary Louise Chatel**
Client **Parham Santana**

This promotion's distinctive odor was hard for its
recipients to ignore. "Our office was scented for an entire
month after we worked with more than 800 of these
fresheners," says principal Maruchi Santana. "But clients
remember this piece as one of our most creative
promotions."

2

Design Firm **Hoffmann & Angelic Design**
Art Director **Ivan Angelic**
Designer **Andrea Hoffman**
Calligrapher **Ivan Angelic**
Client **Hoffmann & Angelic Design**

This piece's use of pop-up hands catches attention and
reinforces its promotion of a hand lettering service. In
response to this clever piece, "We got plenty of inquiries,"
says firm principal Ivan Angelic.

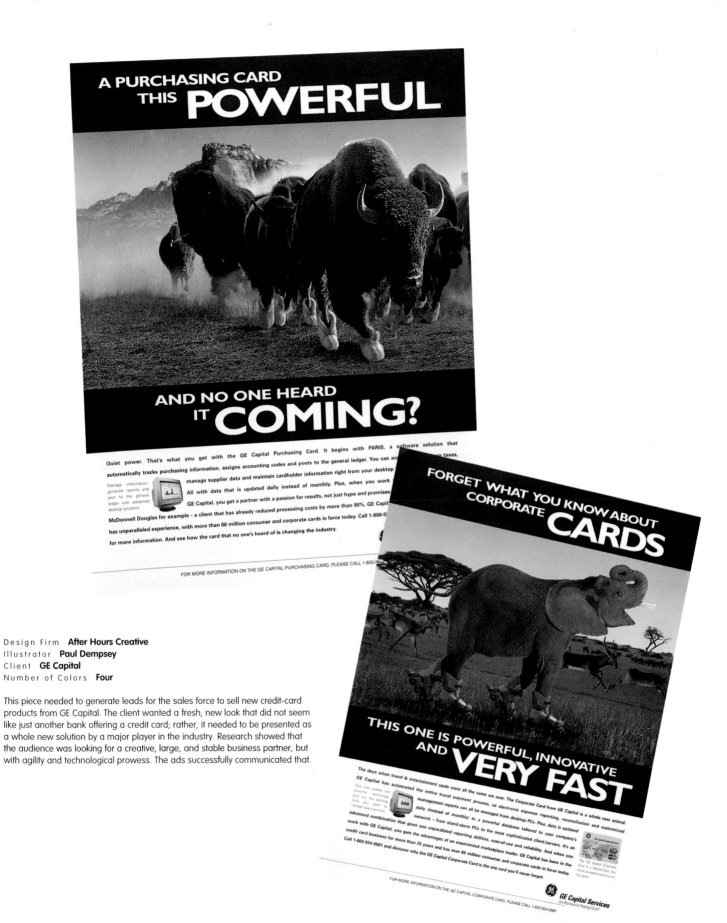

Design Firm **After Hours Creative**
Illustrator **Paul Dempsey**
Client **GE Capital**
Number of Colors **Four**

This piece needed to generate leads for the sales force to sell new credit-card products from GE Capital. The client wanted a fresh, new look that did not seem like just another bank offering a credit card; rather, it needed to be presented as a whole new solution by a major player in the industry. Research showed that the audience was looking for a creative, large, and stable business partner, but with agility and technological prowess. The ads successfully communicated that.

To see more work by the designers featured in this
book, see these volumes:

The Best Direct Response Design
The Best of Invitation, Card, and Announcement Design
Digital Design
Direct Mail Marketing Design
and
Postcard Graphics